IMAGES
of Modern America

TAMPA BAY LANDMARKS AND DESTINATIONS

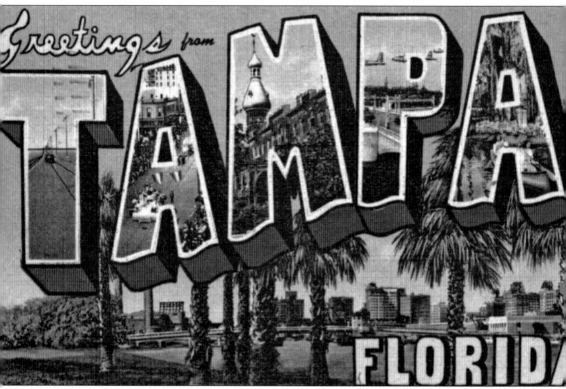

This colorful postcard typifies Tampa, Florida, during the mid-20th century, when the city and the rest of the bay area as a whole became a popular playground for people from all over the United States. (Courtesy of the University of South Florida Library Special Collections Department.)

On the Front Cover: Clockwise from top left:
Clearwater Beach and Pier 60 (University of South Florida Library Special Collections Department), the Gasparilla pirate parade is an annual Tampa tradition dating back to 1904 (Florida State Archive), the Python was the first Florida roller coaster to turn riders upside down (Florida State Archive), Ben Zobrist bats for the Tampa Bay Rays (City of St. Petersburg), the 1954 (left) and 1987 (right) spans of the Sunshine Skyway Bridge coexisted for a period during the late 1980s and early 1990s (Florida State Archive)

On the Back Cover: From left to right:
The Florida State Fair is seen in its downtown Tampa location in 1964 (Florida State Archive), Adventure Island® is a major Tampa water park that has soaked guests since 1980 (Florida State Archive), Fort De Soto is where wartime history and natural beauty meet on the Gulf of Mexico in Tierra Verde (City of St. Petersburg)

IMAGES
of Modern America

TAMPA BAY LANDMARKS AND DESTINATIONS

Joshua McMorrow-Hernandez

ARCADIA
PUBLISHING

Published by Arcadia Publishing
Charleston, South Carolina

Printed in the United States of America

Library of Congress Control Number: 2014950157

For all general information, please contact Arcadia Publishing:
Telephone 843-853-2070
Fax 843-853-0044
E-mail sales@arcadiapublishing.com
For customer service and orders:
Toll-Free 1-888-313-2665

Visit us on the Internet at www.arcadiapublishing.com

I dedicate this book to all my loved ones and those who have supported me along the way. I would not be where I am in my life without you. I am forever grateful.

CONTENTS

Acknowledgments

I would like to express my gratitude to the many people who helped make this book possible. First, I want to thank my better half, Katya, who assisted me in countless ways and encouraged me throughout the process of researching for and writing this book. I am also grateful to Dad, Kelly, Michele, and the rest of my loving clan and circle of friends for their continued encouragement and support. Most of the photographs in this book came from resources other than my own, and I am truly appreciative to have received the assistance of numerous individuals and organizations. I must first thank Andrew Huse, Barbara Lewis, and Matt Knight at the University of South Florida Library Special Collections Department; the staff at the Tampa-Hillsborough Public Library; Tampa historian John Cinchett; Dan Perez at tampapix.com; and Adam Watson at the Florida State Archive—all have worked with me before on other projects and so kindly lent their time and resources to me again for this book.

I also thank Jamie Stetson and Travis Claytor at SeaWorld Parks & Entertainment, Inc.; Anthony Gonzalez and Jill Witecki at the Tampa Theater; Katherine Claytor at the Florida Aquarium; the Manatee County Historical Records Library; Mike Clark at big13.com; Paul Bilyeu at the Straz Center for the Performing Arts; Adam Watson at the Florida State Archive; Jim Schnur at the University of South Florida St. Petersburg Nelson Poynter Memorial Library; Katie Pedretty at Ruth Eckerd Hall; Betsy Rosado at the Salvador Dalí Museum of St. Petersburg, Florida; April Troyer at the Clearwater Public Library; Eric Blanc and Robin Franco at the Tampa Convention Center; Alice and Don Morris at H&R Trains; Marlene Svensson at Dinosaur World; Shannon Herbon and Don Toeller at the Museum of Science and Industry; Rachel Nelson at Lowry Park Zoo; Tobey Carter at Quality Street Fabricators, Inc.; Courtney King with the City of Dunedin; Ray Hinst and Ryan Abel at Haslam's Bookstore; Tyler Rowland of the Clearwater Marine Aquarium; Nathan March with the Pittsburgh Pirates; Mark and Dylan Hubbard at Hubbard's Marina; R. Wayne Ayers; Glenn Bomke; Yvonne Colado Garren; Roger Bansemer; Casanova Nurse; Gene Adler; Chad Freeman; Cush Revette; Hudson Eugene Holloway; and Donna Skibo.

Last but not least, I want to thank my title manager, Liz Gurley, and the entire staff at Arcadia Publishing for their support of this project.

Trademarks and registered marks on pages 2 and 11–13 belong to SeaWorld Parks & Entertainment, Inc.

INTRODUCTION

When Pánfilo de Narváez and Hernando de Soto arrived in the Tampa Bay region during the first decades of the 1500s, they and their crews were looking for gold. While the Spanish explorers found none of the precious yellow-colored metal in west central Florida, the natural beauty of the Tampa Bay area is definitely worth its weight in gold. The region has drawn millions of tourists from all over the world since. Many of these visitors have become full-time residents, drawn to the area by its white Gulf Coast beaches, subtropical and temperate flora and fauna, countless lakes, and flourishing arts and entertainment scene.

While the region is commonly referred to as Tampa Bay today, this is not the name of any city; this is a common misconception partly caused by the names of local professional sports teams (such as professional football's Tampa Bay Buccaneers and baseball's Tampa Bay Rays) as well as a host of players in the tourism and commerce industries. The hub of the bay area is Tampa itself. The city would arise following the creation of a frontier post called Fort Brooke, which was established in 1824 by the US Army in the area where the Tampa Convention Center stands today. Fort Brooke served during three Seminole Wars and the Civil War before it was decommissioned in 1883. By then, a small village had grown around the fort, which by 1849 would be incorporated as Tampa. Tampa, for the record, is a name that is thought by many to mean "sticks of fire" in the language of the Calusa Native Americans who lived just south of Tampa Bay for centuries. Sticks of fire may refer to frequent summertime lightning strikes in the area or a place to gather sticks of wood for campfires. While the Tampa name has Calusa origins, the immediate bay area was actually populated by the Tocobaga people.

The 1880s would see the beginnings of the phosphate and cigar industries in the Tampa area. At the same time, railroad magnate Henry Bradley Plant spearheaded the development of local rail lines, helping put Tampa on the map as a tourism destination and industrial epicenter. A savvy developer, Plant also constructed his beautiful Tampa Bay Hotel in 1891. This grandiose building near the Hillsborough River has since been incorporated into the University of Tampa campus and graces the skyline with domes, turrets, and minarets.

While Plant was busy building his majestic hotel in Tampa, which had been officially charted as a city in 1887, two developers named Peter Demens and John C. Williams were already hard at work across the bay, laying the groundwork for the city of St. Petersburg. In 1888, Demens, who spent much of his youth growing up in St. Petersburg, Russia, built the Detroit Hotel—named for the city where Williams was born and raised. The hotel, which was built for visitors rolling in on the local Orange Belt Railway Demens introduced, has been significantly modified over the years and stands today at 215 Central Avenue as a condominium complex.

The area of present-day Clearwater was originally inhabited by the Tocobaga people, and in 1835 Fort Harrison was established by the US Army. Fort Harrison was built on a bluff near Clearwater Harbor and served during the Seminole Wars. Settlement brought farming pioneer families to the region, and the community of Clear Water Harbor, a name thought to have arisen

from a freshwater spring near where the current city hall building stands, would be established in 1891. The city of Clearwater was incorporated in 1915. By then, Henry B. Plant, who was enjoying success as the proprietor of the Tampa Bay Hotel across the bay, had helped propagate tourism in the Clearwater area with the construction of his Victorian-style Belleview Biltmore resort hotel in 1897.

Many of the smaller cities and towns in the region such as Bradenton, Dunedin, and Largo were incorporated around the turn of the 20th century. The warm mineral water at Sulphur Springs would draw tourists to Tampa during the first decades of the 20th century, while St. Petersburg first hosted baseball spring training in 1914. Clearwater Beach was linked to the mainland by bridge in 1915, baseball began spring training at McKechnie Field in Bradenton in 1923, and Tampa Downs (later Tampa Bay Downs) brought thoroughbred horse racing to Oldsmar in 1926. All of these attractions were among the many frequented by the so-called Tin Can Tourists who began arriving in the Tampa Bay area by the winter of 1919–1920, following the economic prosperity after World War I and the burgeoning popularity of the automobile.

Like the rest of the country, Florida was struck hard by the economic turmoil of the Great Depression, and matters in the Sunshine State were made all the worse as the land boom of the 1920s had gone bust before the Roaring Twenties rolled away. The 1930s brought tough times for many Tampa-area families, but the region would see several Works Progress Administration (WPA) projects spring up under the New Deal. Perhaps the most famous of these Tampa Bay area WPA projects were improvements along Bayshore Boulevard in 1935 that led to wider pavement and construction of a 4.5-mile stretch of sidewalk—the longest continuous sidewalk in the world. Other New Deal projects in Tampa included the construction of Drew Field, Peter O. Knight Airport, the Fort Homer W. Hesterly Armory, and repairs to the Tampa Bay Hotel.

Economic fortunes changed for the better in the Tampa area following World War II. The decades of the 1940s and 1950s saw a major population boom in the Sunshine State, with its number of residents increasing from 1,897,414 in 1940 to 4,951,560 by 1960. Roadside attractions flourished, bringing tourists to the Kapok Tree Inn in Clearwater, shining the spotlight on Sunken Gardens in St. Petersburg, and prompting the opening of Lowry Park Zoo in Tampa. In 1959, American brewer Anheuser-Busch built Busch Gardens as a free visitor center for guests who wanted to tour the company's on-site brewery. By the end of the 1970s, the park had become internationally known for its exotic animals and thrill rides.

The 1960s and 1970s saw major changes in the Tampa Bay area, including the construction across Florida of the iconic Interstate 4, which is now flanked with tourist attractions of every size and scale imaginable, including Walt Disney World. The Tampa area saw a multitude of tourist attractions open in the region, including Tussaud's London Wax Museum and the Aquatarium in St. Petersburg, Tiki Gardens in Indian Shores, South Florida Museum in Bradenton, Treasureland in Tampa, and Clearwater Marine Science Center, later renamed Clearwater Marine Aquarium.

The 1980s and 1990s saw changing times for the Tampa Bay area's tourism scene, as many of the larger attractions in Orlando and Kissimmee became prime draws for visitors to the state. Smaller attractions in the bay area were forced to adapt to the changes in tourism traffic, but many were left with dwindling attendance numbers and eventually closed.

Today, the Tampa Bay area has grown to become a dynamic player in the international tourism industry. Photographs of sunny beaches, happy boaters, and baseball spring training games still grace local tourist literature just as they did a century earlier. However, the region is also now widely known for its emerging arts and culture scene, delicious menu of epicurean options, and vibrant nightlife. What will become of the Tampa Bay area's tourism industry in the years to come? If the past is any indication, then we know that the Tampa Bay area will remain in the national, and international, tourism spotlight as a unique region where sun meets surf, citrus seasons the local flavor, and residents and tourists alike have boundless ways to enjoy the day.

One

AMUSEMENT PARKS
AND ATTRACTIONS

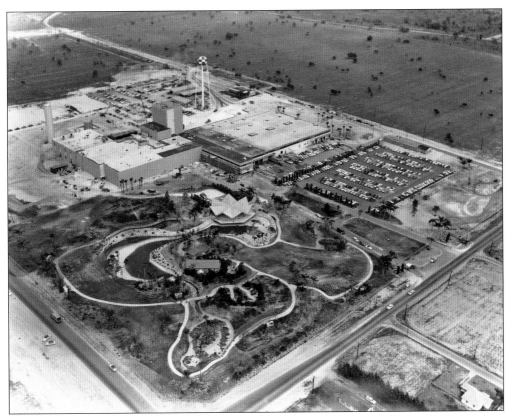

This 1959 aerial view of Busch Gardens shows the entire park during its first year of operation. The Anheuser-Busch brewery facility is seen in the middle of the photograph, and the Hospitality House, with its unique roof, is seen in the upper right corner of the botanical bird gardens section. A two-lane Busch Boulevard, then called Temple Terrace Highway, is seen along the bottom of the image. (Courtesy of the Tampa-Hillsborough Public Library.)

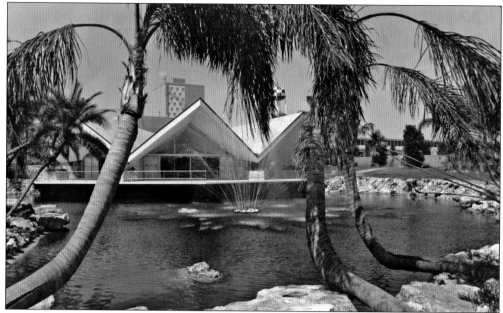

On March 31, 1959, Anheuser-Busch, Inc., opened the company's fourth brewery in Tampa and with it a 15-acre garden showcasing exotic birds and landscaping. Guests could tour the gardens for no charge and sample free beer in the Hospitality House, pictured here in front of the brewery facility towering in the background. (Courtesy of the Tampa-Hillsborough Public Library.)

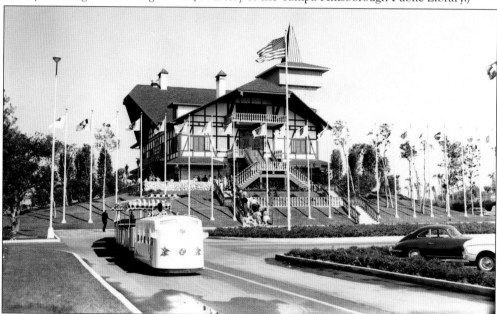

The Old Swiss House Restaurant, an enlarged replica of the famous restaurant of the same name in Lucerne, Switzerland, opened in November 1964. The restaurant offered fine dining overlooking free-roaming wildlife and also contained an antique collection of rare beauty. In early 1990, the hospitality center and newly remodeled Crown Colony House opened as a family dining experience capturing the feel of adventure and romance of the African colonial era. (Courtesy of the Florida State Archive.)

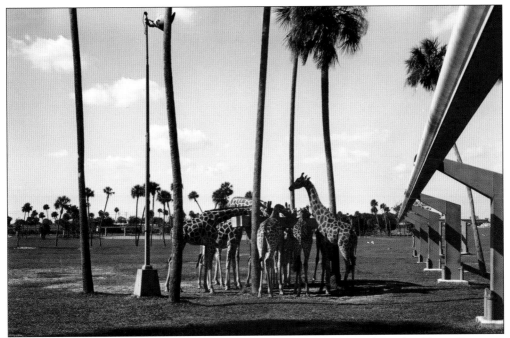

This 1967 view from Busch Gardens' monorail shows giraffes feeding on the park's 65-acre Serengeti Plain®. Otherwise known as the Veldt, this unique expanse is inhabited by free-roaming African animals and represents just one of the many first-of-a-kind, naturalistic animal habitats that Busch Gardens has introduced over the years. (Courtesy of the Florida State Archive.)

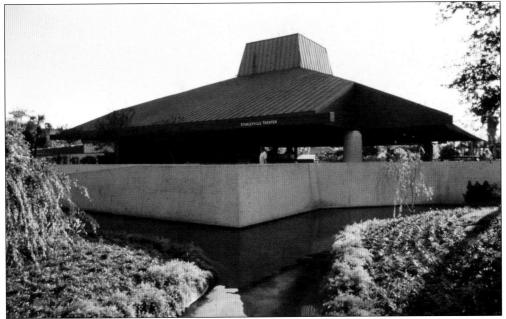

The Stanleyville Amphitheater® was originally called the Tanzania Theater when it opened in 1972. The theater has showcased a wide range of world-class entertainment over the years, including animal performances, the Stanleyville Variety Show, Siegfried and Roy protégé illusionist Darren Romeo, and countless concerts. (Courtesy of the Florida State Archive.)

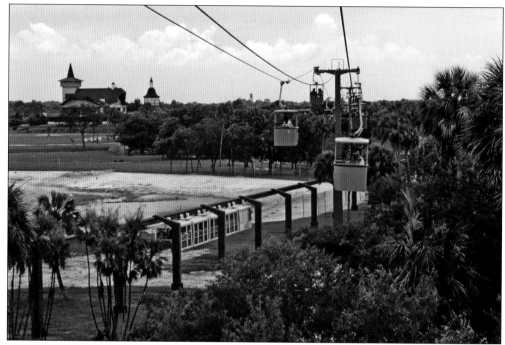

The Skyride®, which opened in 1974, is just one mode of transportation guests can enjoy during a day at Busch Gardens. The park's monorail, which operated from 1966 through 1999, can be seen meandering through the middle of this image. The park also offers the Trans-Veldt Railway®, a 19th-century-inspired narrow-gauge steam railroad that first chugged along its two-mile track in 1971. (Courtesy of the Florida State Archive.)

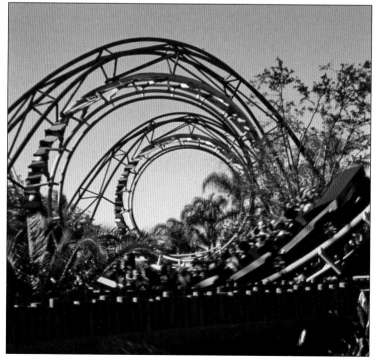

In 1976, Busch Gardens opened its first roller coaster, the Python. Featuring 1,200 feet of track, a six-story dive, and two corkscrew loops, the Python was the first inverted roller coaster in Florida and ushered in the park's era of building some of the most thrilling rides in the United States—a tradition that continues today with roller coasters like Kumba®, Montu®, and SheiKra®, and the Falcon's Fury™ drop tower. (Courtesy of the Florida State Archive.)

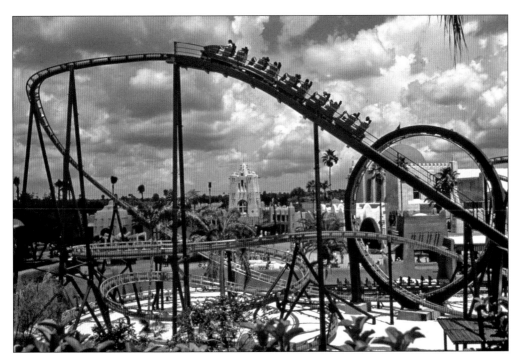

In 1980, Busch Gardens completed one of its largest expansion projects with the opening of Timbuktu®. The themed section, inspired by the African desert city of the same name, contained several attractions, including the Scorpion® roller coaster, seen here in the foreground, and Das Festhaus®, a large German-inspired restaurant pictured to the right. The Timbuktu® area was reimagined in 2014 as Pantopia® and features Falcon's Fury™, a 335-foot-tall drop tower. (Courtesy of the Florida State Archive.)

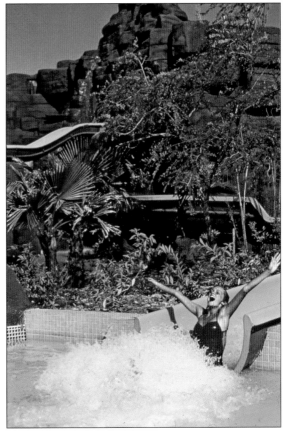

In 1980, Busch Gardens opened Adventure Island®, a water park that is adjacent to the African-themed Busch Gardens and has since grown to 30 acres. Featuring dozens of attractions, including slides, pools, and rides, Adventure Island® appeals to children and adults alike and is one of the most popular water parks in Florida. (Courtesy of the Florida State Archive.)

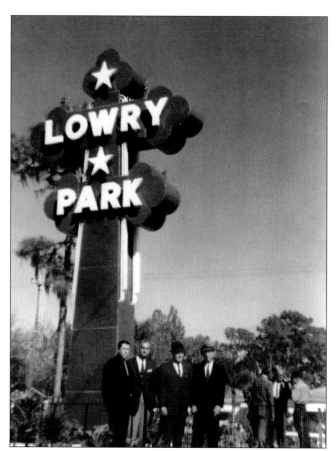

Lowry Park Zoo, opened in 1957, was Tampa's second zoo and named after local resident Gen. Sumter Loper Lowry, who made many civic contributions and served in both World Wars. The city's first zoo was established in Plant Park during the 1930s, and it housed raccoons, alligators, and exotic birds, many of which were moved to Lowry Park Zoo. (Courtesy of the Cinchett collection.)

During its early years, Lowry Park Zoo featured a whimsical area called Fairyland. Guests could access Fairyland by crossing the zoo's popular rainbow bridge, seen here in the 1960s. (Courtesy of the University of South Florida Library Special Collections Department.)

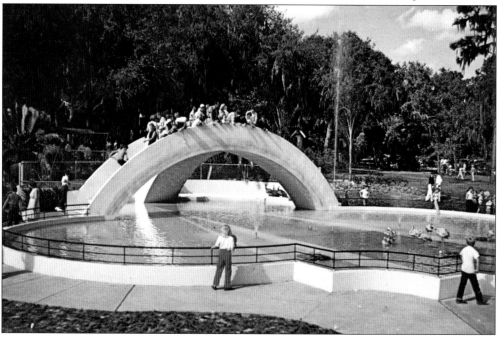

This is Lowry Park Zoo's Fairyland, enchanting children with scenes populated by elves and fairies and colorful depictions of popular nursery rhymes and fables. Fairyland was a popular attraction for families visiting Lowry Park Zoo during its first decades and provided a whimsical element to the zoological facility. (Author's collection.)

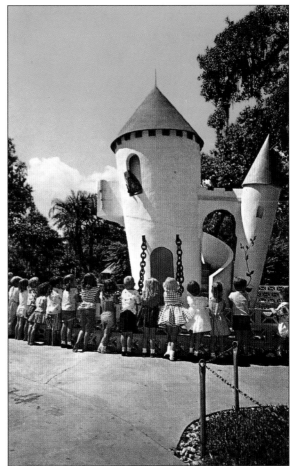

Lowry Park Zoo presented a free elephant and chimpanzee show during its early years. Following a massive renovation focused on upgrading its animal habitats, the 56-acre Lowry Park Zoo reopened in March 1988 and has since been voted the no. 1 family-friendly zoo in the United States by *Parents* magazine. (Author's collection.)

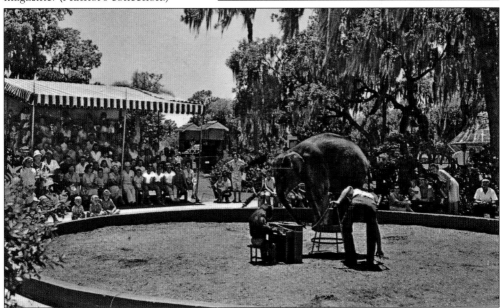

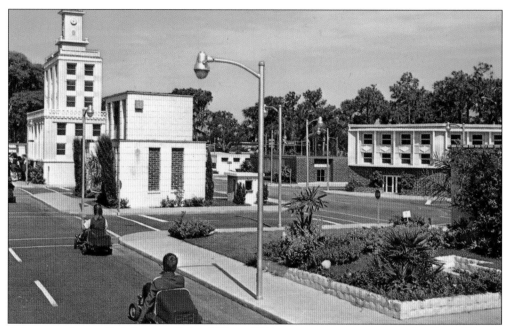

Adjacent to Lowry Park Zoo was Safety Village, USA, a miniature community the City of Tampa opened in 1965 to teach children traffic safety. Safety Village evolved into a small replica of Tampa and was eventually renamed Kid City. Sadly, this unique attraction was demolished in 2010. (Author's collection.)

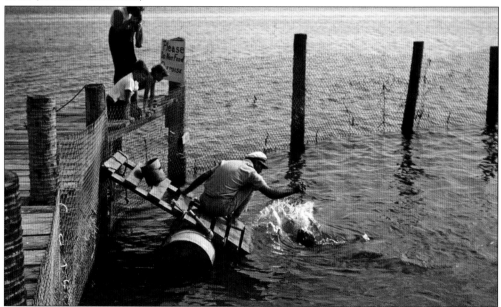

Capt. Wilson Hubbard, who operated fishing charters on Pass-a-Grille, ran Shell Island Sea Ranch in the 1950s. The marine attraction allowed guests to meet dolphins, including Paddy the Porpoise, who is seen here being fed by Hubbard. As Hubbard's fishing business grew, he would focus on his charters and gifted Paddy to the Marine Arena aquarium in Madeira Beach. Since the 1980s, Hubbard's Marina has again turned its attention to cetaceans, now offering dolphin tours in the Gulf of Mexico. (Courtesy of Hubbard's Marina.)

In 1953, the Marine Arena aquarium, owned by Jack Hurlbut, opened on the Madeira Beach side of John's Pass Bridge. The 50,000-gallon aquarium was billed as the largest on Florida's west coast and was widely popular with tourists who came to see its many exotic marine animals. The Marine Arena closed in 1965, just a year after the much larger Aquatarium opened on St. Petersburg Beach. (Courtesy of R. Wayne Ayers.)

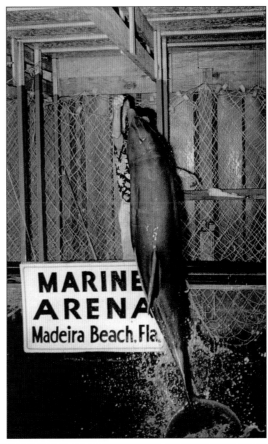

In 1964, Marine Attractions, Inc., built the 17-acre Aquatarium on St. Petersburg Beach between Sixty-fourth and Sixty-sixth Avenues. The Aquatarium featured dolphin shows and a large collection of other marine animals. The popular attraction saw declining crowds in the 1970s due in part to the arrival of Orlando-area attractions, and the facility was rebranded as Shark World in 1976, following the success of the recent Steven Spielberg movie *Jaws*. Failing to take a significant bite out of the competition, the facility closed in 1977. (Author's collection.)

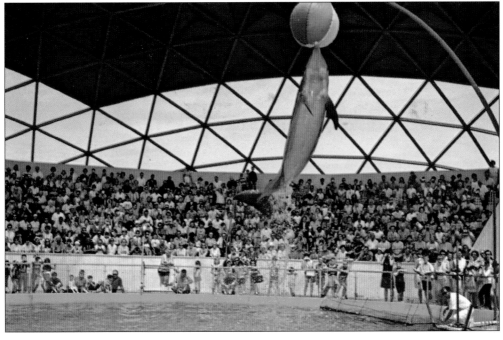

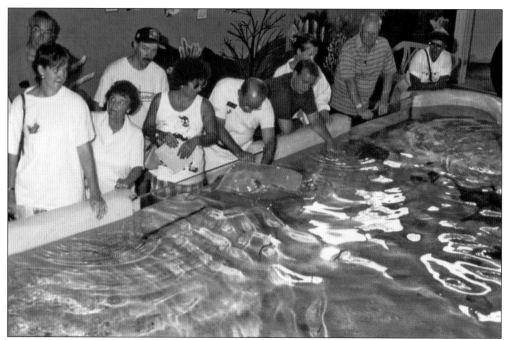

Clearwater Marine Aquarium (CMA) opened in 1972 as the Clearwater Marine Science Center and attracts tourists with exhibits such as this stingray touch habitat. In 2005, CMA adopted Winter, a bottlenose dolphin that the facility rescued from entanglement in crab trap ropes that cut off blood supply to her tail, resulting in its loss. CMA and a team of experts created a special prosthetic tail to help her swim normally. (Courtesy of the Florida State Archive.)

Giant's Fishing Camp is just one of the many landmarks that typify the eclectic circus atmosphere of Gibsonton, the winter home of many Ringling Bros. and Barnum & Bailey Circus performers. The camp was run by "Giant Boy" Al Tomaini, a sideshow performer who was listed in the Guinness World Records as standing 7 feet, 11 inches tall. His wife was Jeanie, otherwise known as "Half Girl," a woman born without legs. (Author's collection.)

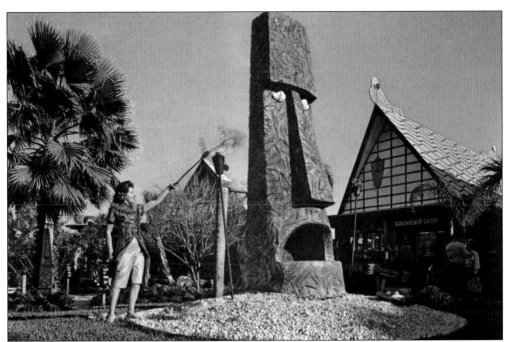

In 1962, Tiki Gardens was opened in Indian Shores on Gulf Boulevard by "Trader" Frank and Wahine Jo Byars. Featuring Polynesian-themed gardens, exotic birds, monkeys, and Trader Frank's Restaurant, Tiki Gardens was situated adjacent to the Byars's Signal House gift shop. Byars sold the property in 1986 to foreign investors, who in turn vended the land to Pinellas County in 1990. The property is now a beach parking lot. (Courtesy of the Florida State Archive.)

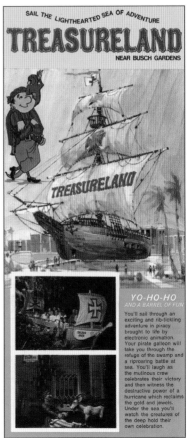

SAIL THE LIGHTHEARTED SEA OF ADVENTURE

TREASURELAND

NEAR BUSCH GARDENS

YO-HO-HO
AND A BARREL OF FUN

You'll sail through an exciting and rib-tickling adventure in piracy brought to life by electronic animation. Your pirate galleon will take you through the refuge of the swamp and a riproaring battle at sea. You'll laugh as the mutinous crew celebrates their victory and then witness the destructive power of a hurricane which reclaims the gold and jewels. Under the sea you'll watch the creatures of the deep hold their own celebration.

Located at 4115 East Busch Boulevard in Tampa, Treasureland was a 1960s indoor attraction that allowed its guests to enjoy a lighthearted look at pirate culture with colorful displays and animatronics. Treasureland also told the story of José Gaspar, the legendary pirate for whom Tampa's annual Gasparilla parade is named. In the late 1970s, Hudson Eugene Holloway turned the site into his popular Sea Wolf restaurant. (Author's collection.)

19

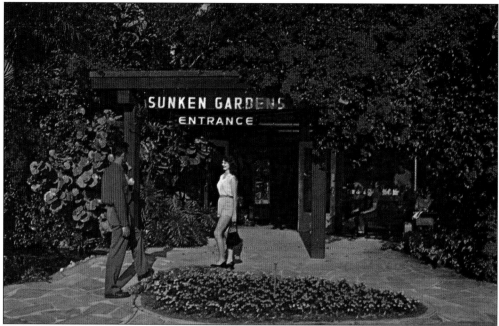

Sunken Gardens is a four-acre botanical paradise in St. Petersburg encompassing more than 50,000 plants and flowers from around the world. The popular attraction's roots trace back to 1903 when gardener George Turner Sr. purchased the land and drained a shallow lake sitting 10 feet below sea level to form a sunken garden. By the 1920s, Turner sold fruits and plants, and charged 5¢ admission to tour his nursery. Over the decades, the attraction has grown to become an iconic landmark at 1825 Fourth Street North. (Author's collection.)

In the 1950s and 1960s, SuperTest Oil & Gas operated an amusement park at 2924 North Dale Mabry Highway and Columbus Avenue in Tampa. The park featured a merry-go-round, Ferris wheel, train ride, animals, and other attractions that delighted locals and tourists. After years of drawing huge crowds, the site became the Hubert Brooks Dodge dealership in 1968 and is now Jerry Ulm Dodge. (Courtesy of the Tampa-Hillsborough Public Library.)

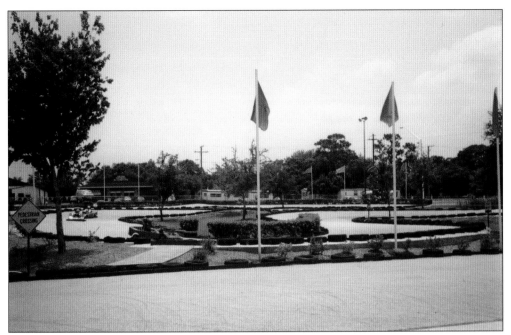

In 1978, Malibu Grand Prix opened at 14320 North Nebraska Avenue in Tampa and quickly became a playground for kids and adults alike. Offerings at this popular 15-acre destination, which is now called Grand Prix Tampa, include a half-mile racetrack with scaled down Indy-style racecars, a go-kart track, two 18-hole miniature golf courses, and an arcade, among other attractions. (Author's collection.)

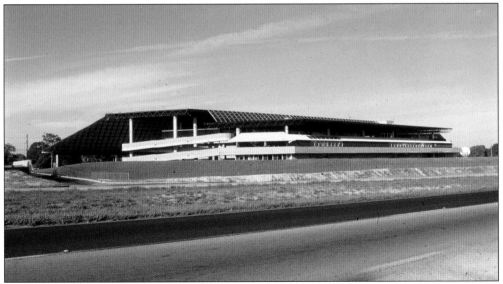

Following years of development by the Hillsborough County Museum, the Museum of Science and Industry (MOSI) was completed in 1980 and permanently opened to the public in 1982. Throughout the 1980s and early 1990s, the postmodern building (pictured) at 4801 East Fowler Avenue in Tampa was the primary exhibit area. In 1995, MOSI expanded its facility, adding new exhibit and event space and an IMAX theater within a distinctive, 85-foot-tall domed building. (Courtesy of the University of South Florida Library Special Collections Department.)

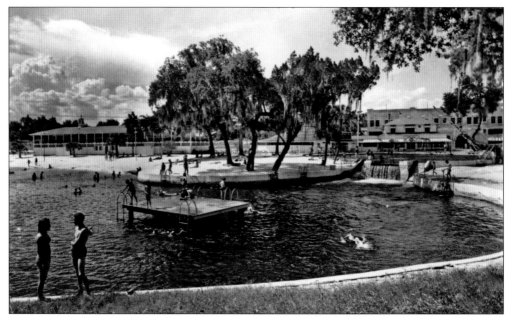

In 1906, Josiah Richardson bought the property that soon became known as Sulphur Springs. A pool complex fed by a natural spring was built there, offering a high dive, bathhouse, gazebo, and toboggan slide pictured here. The Sulphur Springs pool complex was a popular destination for tourists and locals alike, but contamination of the natural spring from sinkholes and storm runoff forced the closure of this beloved attraction in 1986. (Courtesy of the Tampa-Hillsborough Public Library.)

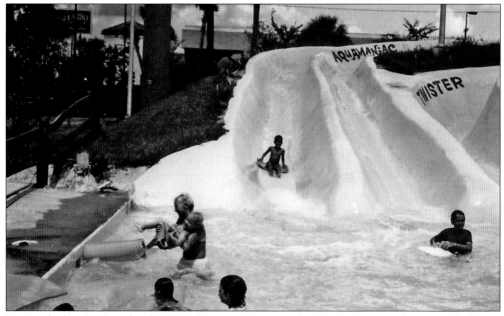

During the late 1970s and early 1980s, Aquamania operated on Fowler Avenue about one block west of Twenty-second Avenue just south of University Square Mall. Aquamania was one of the Tampa Bay area's first water parks, offering slides and pools for its leisure-seeking guests. This photograph was taken in 1982, shortly before Aquamania's closing. (Courtesy of Casanova Nurse.)

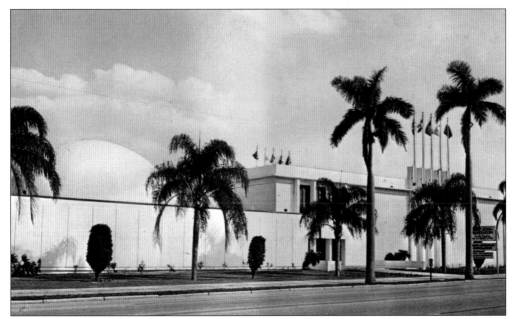

The South Florida Museum originally opened on Bradenton's Memorial Pier in 1947. Two years later, a West Indian manatee named Baby Snoots arrived at the facility. In 1966, the museum moved to its current site, pictured here, and added the Bishop Planetarium. Further additions include the 16th-century Spanish plaza and the 60,000-gallon Parker Manatee Aquarium. (Courtesy of the University of South Florida Library Special Collections Department.)

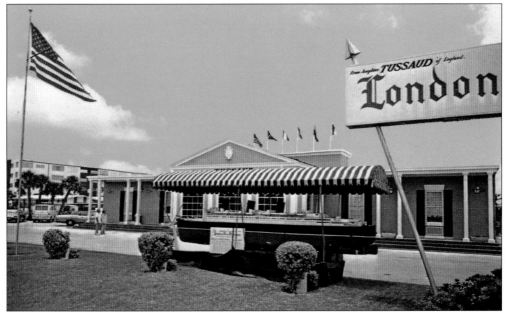

Tussaud's London Wax Museum opened on March 2, 1963, at 5505 Gulf Boulevard in St. Petersburg Beach. Featuring more than 120 wax figures, including Hollywood stars, world leaders, and other recognizable figures, the museum was a popular attraction with tourists during the 1960s and 1970s. By the 1980s, tourists had grown accustomed to animatronic figures, and the still-life stars had difficulty attracting many guests. The museum closed on January 15, 1989. (Author's collection.)

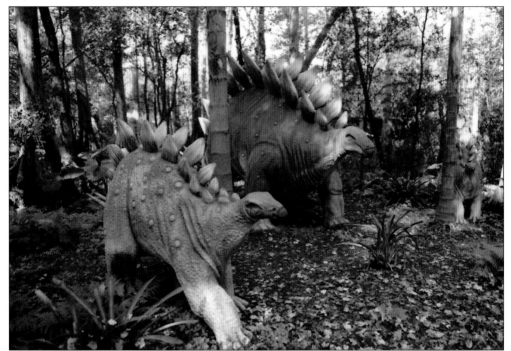

Dinosaur World, located in Plant City off Exit 17 from Interstate 4, has been entertaining locals and tourists alike for years. Featuring more than 200 life-size dinosaurs and related exhibits, including real fossils, Dinosaur World is popular with families and those interested in prehistoric studies. (Courtesy of Dinosaur World.)

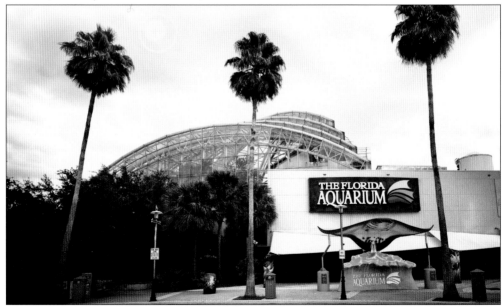

The Florida Aquarium opened its doors on March 31, 1995. In the years since its opening, the facility has served as an important player in the conservation and research of marine species native to the Sunshine State and has grown to become one of the top five kid-friendly aquariums in the country according to *Parents* magazine. (Courtesy of The Florida Aquarium.)

Two

VENUES AND EVENTS

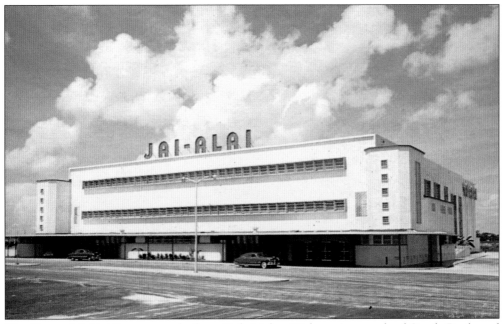

The Tampa Jai Alai fronton was built on Dale Mabry Highway just south of Gandy Boulevard on December 19, 1953. Jai alai, a variation of Basque pelota that is dubbed "the fastest sport in the world," was massively popular during the 1960s, 1970s, and early 1980s and drew standing-room-only crowds to the fronton. By the 1990s, other forms of gambling would lure many of the crowds away, and the fronton closed on July 4, 1998. It was soon demolished to make way for retail development. (Author's collection.)

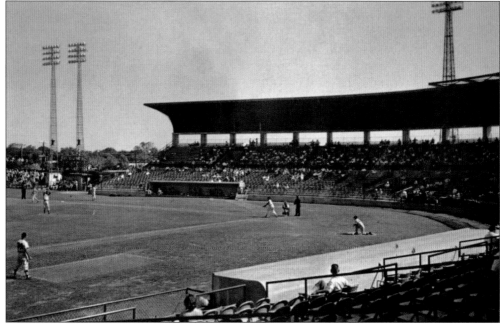

Al Lopez Field opened for spring training in March 1955 near the northwest corner of Himes Avenue and Tampa Bay Boulevard, where Raymond James Stadium stands today. Named for hall of famer and Tampa native Al Lopez, the facility was first used by the Chicago White Sox and later the Cincinnati Reds. Al Lopez Field was demolished in 1989. (Courtesy of the University of South Florida Library Special Collections Department.)

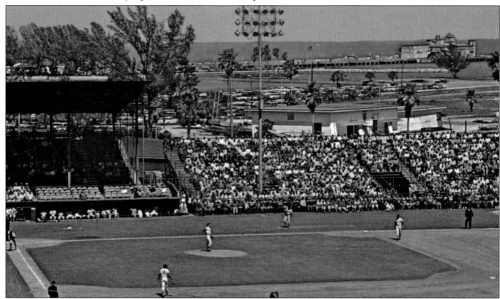

St. Petersburg, which has hosted spring training for a litany of baseball teams since 1914, built Al Lang Field in 1947. Named in honor of the former mayor who originally introduced spring training to St. Petersburg, Al Lang Field would be rebuilt and renamed Al Lang Stadium in 1977, about the same time that the city first suggested hosting its own major-league baseball team. (Courtesy of the University of South Florida Library Special Collections Department.)

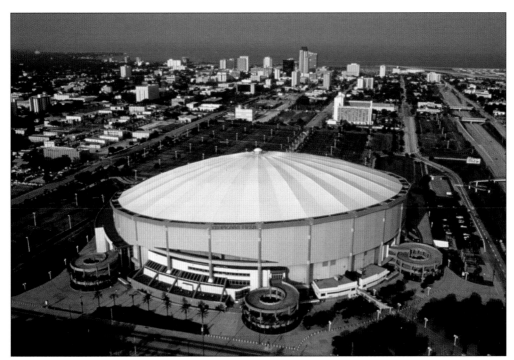

The Florida Suncoast Dome opened in 1990 and would host the Arena Football League's Tampa Bay Storm beginning in 1991. Two years later, the National Hockey League's Tampa Bay Lightning charged into the facility, which was then aptly renamed the Thunderdome. The arrival of major-league baseball in St. Petersburg was finally announced in 1995 and, following major renovations to the facility, the newly renamed Tropicana Dome first hosted the Tampa Bay Devil Rays on March 31, 1998. (Courtesy of the City of St. Petersburg.)

McKechnie Field in Bradenton originally opened as City Park in 1923. In 1962, the field was renamed to honor Bradenton resident Bill McKechnie. He was inducted into the Baseball Hall of Fame for his years playing and managing for many teams, including the Pittsburgh Pirates, who would make the facility their spring training home beginning in 1969. This image, from the early 1970s, shows Pirates hall of famer Bill Mazeroski batting. (Courtesy of the Pittsburgh Pirates.)

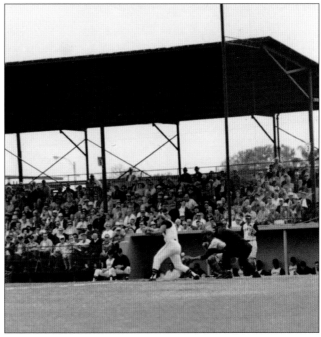

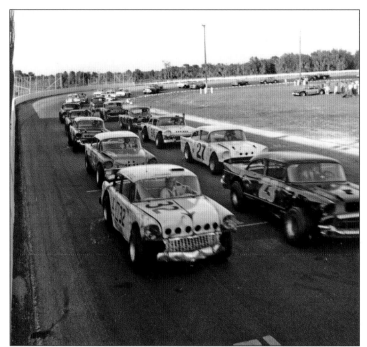

Auto racing was especially popular in the Tampa Bay area during the 1950s through 1970s. St. Petersburg had Sunshine Speedway, Bradenton is the site of Desoto Speedway, and Riverview remains the home of East Bay Raceway. Tampa fielded several racetracks, including Plant Field and Phillips Field near downtown, Speedway Park off Hillsborough Avenue north of Tampa International Airport, and Golden Gate Speedway, seen in this 1966 photograph. (Courtesy of the Florida State Archive.)

Frank Dery opened Golden Gate Speedway on Fowler Avenue near Thonotosassa in 1962. Legendary Tampa driver Cush Revette won the first feature race at Golden Gate Speedway, the site of NASCAR icon Richard Petty's 14th career victory. Races were announced by Gordon Solie, famous for calling the play-by-play during wrestling events at Tampa's Fort Homer W. Hesterly Armory. Golden Gate Speedway closed in 1984 and was replaced by the Big Top Flea Market. (Courtesy of Chad Freeman.)

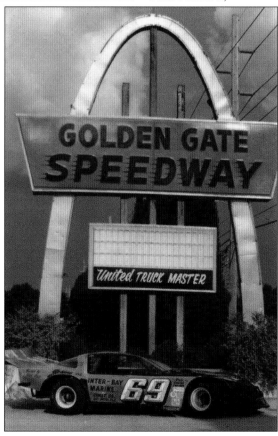

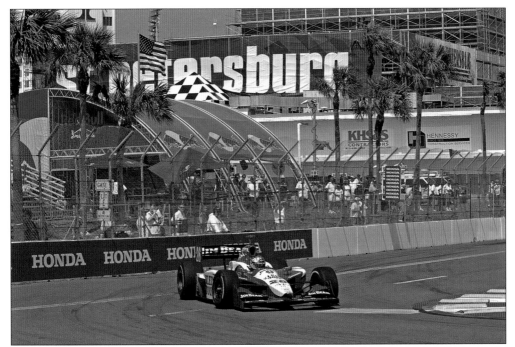

The first grand prix race near the waterfront in downtown St. Petersburg was held in 1985 by the Sports Car Club of America. The Trans-Am series races continued on an annual basis until 1990, when noise complaints forced the event to go on hiatus. In 1996 and 1997, racing briefly resumed in the city on a course around Tropicana Field. In 2003, racing returned for one year and, beginning in 2005, resumed as an IndyCar Series race. (Courtesy of the City of St. Petersburg.)

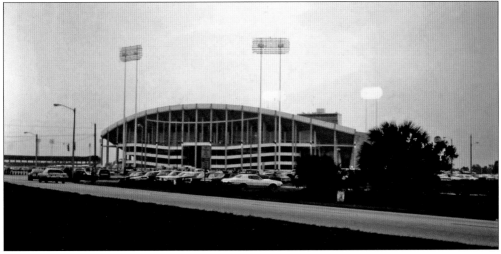

This 1971 photograph shows Tampa Stadium, which opened adjacent to Al Lopez Field in 1967 and was built with the hopes of luring a National Football League team. That goal was scored when the Tampa Bay Buccaneers played their first game there in 1976. Tampa Stadium, later famously dubbed "The Big Sombrero," was outfitted with end-zone seating in the mid-1970s and replaced by Raymond James Stadium in 1998. (Courtesy of Glenn Bomke.)

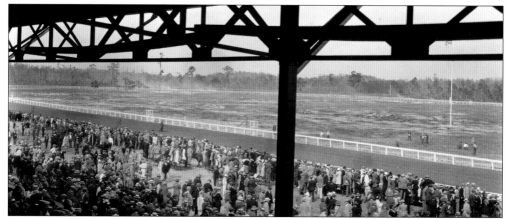

Equine sports have a rich history in the Tampa area, which notably includes the opening of Tampa Bay Downs, originally Tampa Downs, in 1926. The thoroughbred racing facility, seen here, operates at 11225 Race Track Road in Oldsmar and hosts numerous events each year, including an official Kentucky Derby preparatory race called the Tampa Bay Derby. Twelve miles to the east, the annual American Invitational horse show jumping event had been held at Tampa Stadium since 1971 and later moved to Raymond James Stadium. (Courtesy of the Tampa-Hillsborough Public Library.)

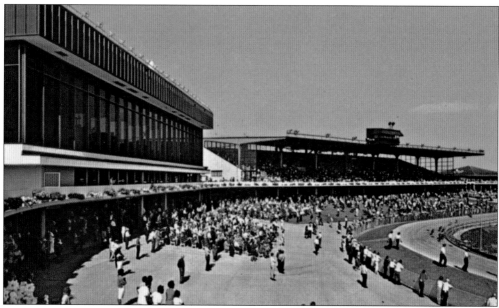

Derby Lanes in St. Petersburg is the world's oldest continuously operating greyhound racetrack. Opened in 1925 as the St. Petersburg Kennel Club, the facility on Gandy Boulevard has become a legendary institution in the sport and during 2006 and 2007 hosted the Derby Lane Million, the richest greyhound stakes race in history. (Courtesy of the University of South Florida Library Special Collections Department.)

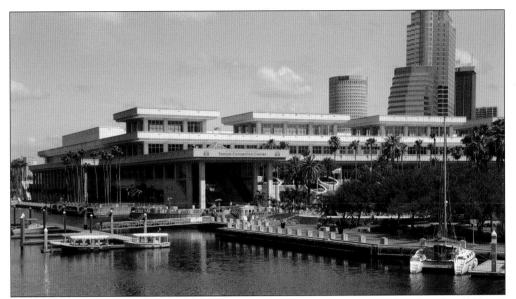

The Tampa Convention Center, located in the heart of the bay area, opened in October 1990 and has hosted a multitude of events since its start, including various trade shows, school graduations, entertainment conventions, and other major events. The 600,000-square-foot facility was built on the historical site of Fort Brooke. In the years immediately before the construction of the convention center, the site had been used for commercial and industrial purposes. (Courtesy of the Tampa Convention Center.)

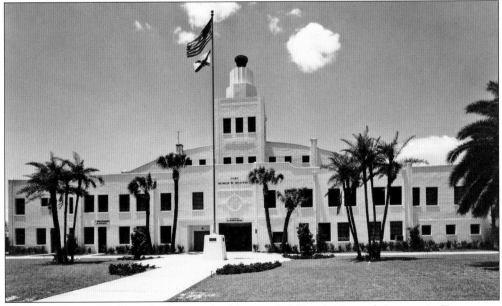

The Fort Homer W. Hesterly Armory building at 522 North Howard Avenue in Tampa was constructed in the 1930s as a New Deal project and dedicated on December 8, 1941—the day after the attack on Pearl Harbor. In the years following World War II, the armory was the scene of many dances, concerts, and other community events, but became locally iconic for hosting professional wrestling matches, which occurred on a regular basis there into the 1980s. (Courtesy of the Tampa-Hillsborough Public Library.)

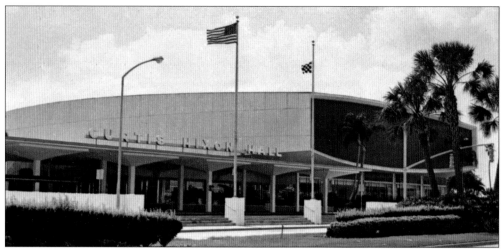

In 1965, Curtis Hixon Hall opened in downtown Tampa. Named for the former Tampa mayor who served from 1943 until his death in 1956, Curtis Hixon Hall accommodated about 7,000 people and hosted conventions, trade shows, annual Gasparilla events, and concerts, including one 1982 J. Geils Band performance for which the then little-known U2 was the opening act. Following the opening of the larger Tampa Convention Center in 1990, the facility was demolished in 1993 and replaced with Curtis Hixon Park. (Courtesy of the University of South Florida Library Special Collections Department.)

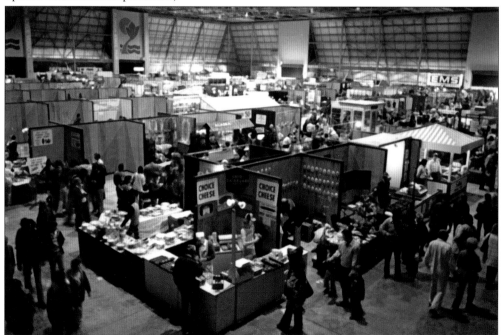

The Expo Hall, built in 1977, is situated on the Florida State Fairgrounds property and primarily used as an exhibit center for the annual fair, trade shows, concerts, and sporting events. The Tampa Bay Rowdies of the North American Soccer League played at the Expo Hall during their 1983–1984 indoor season; the Tampa Bay Lightning of the National Hockey League would also play there during their inaugural season in 1992–1993, before moving to the Thunderdome in St. Petersburg. (Courtesy of the Florida State Archive.)

Bradenton Municipal Auditorium was built around 1960 and has been at the heart of the city's community and civic life for decades. The auditorium is now incorporated into Bradenton City Centre at 1005 Barcarrota Boulevard, adjacent to the Manatee River in the downtown area. (Courtesy of the University of South Florida Library Special Collections Department.)

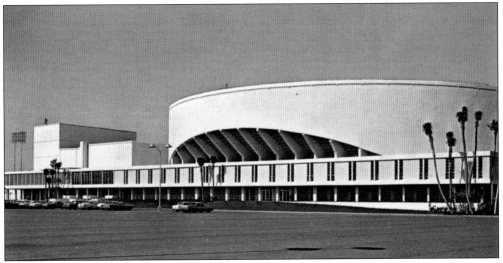

The Bayfront Center was opened in May 1965, with an adjoining 2,000-seat auditorium that would be called the Mahaffey Theater. The main 7,500-seat arena hosted concerts, trade shows, Tampa Bay Rowdies indoor games and other sporting events, ice-skating shows, and annual Ringling Bros. and Barnum & Bailey Circus performances. The Bayfront Center arena was demolished in 2004, and the Mahaffey Theater, which hosts symphonies, stage performances, and other events, received a $20 million face-lift. (Author's collection.)

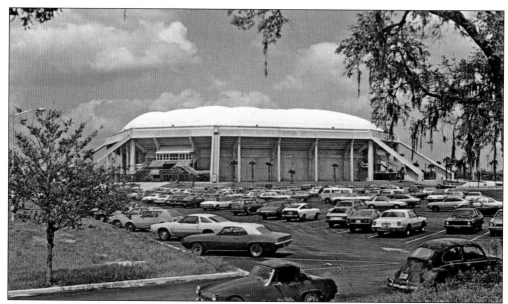

The Sun Dome, located on the University of South Florida (USF) campus, opened in November 1980 and hosts events ranging from USF Bulls basketball games to wrestling competitions to concerts, including performances by Frank Sinatra, Billy Joel, and Elton John. Its distinctive inflatable roof, seen in this photograph, was replaced with a Teflon-coated roof in 2000, and the entire facility later underwent a $35 million face-lift that was completed in 2012. (Courtesy of the University of South Florida Library Special Collections Department.)

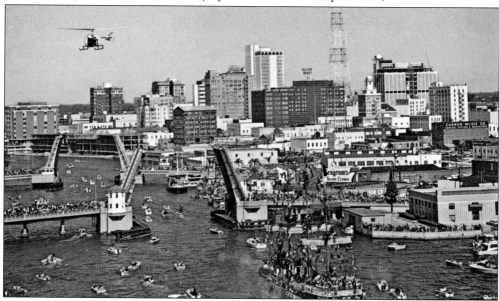

The Gasparilla festival has been an annual Tampa tradition since 1904. Usually held in late January or early February, the Gasparilla festival celebrates the legend of mythical Spanish pirate José Gaspar, who was said to have lurked in southwest Florida. The event, hosted by the City of Tampa and Ye Mystic Krewe of Gasparilla, coincided with the Florida State Fair until the fair moved from its downtown Tampa location in the 1970s. (Courtesy of the University of South Florida Library Special Collections Department.)

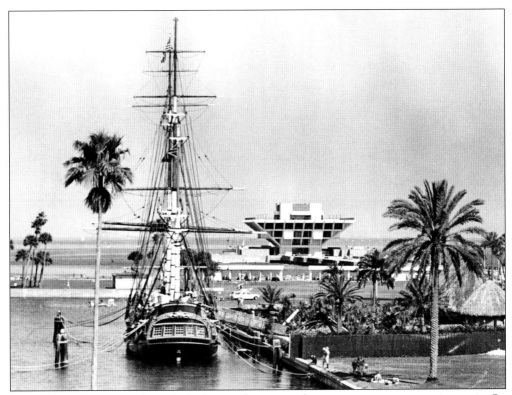

The HMS *Bounty*, seen here docked near the inverted pier structure, was a mainstay in St. Petersburg from 1965 through 1986. The 180-foot-long, 412-ton replica of the 1787 Royal Navy sailing ship was built by Metro-Goldwyn-Mayer Studios in 1960 for the movie *Mutiny on the Bounty*. On October 29, 2012, the HMS *Bounty* met a tragic fate when it sailed into the path of Hurricane Sandy and was destroyed, killing one crew member and washing the captain out to sea. (Courtesy of the City of St. Petersburg.)

The HMS *Southampton* was greeted by thousands of visitors when it docked near downtown Tampa in the late 1980s. The Type 42 destroyer was launched in 1979 and commissioned in 1981. It would serve the Royal Navy until 2009, when the ship was decommissioned and eventually towed to a scrapyard in Turkey. (Author's collection.)

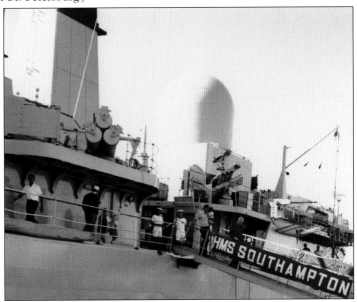

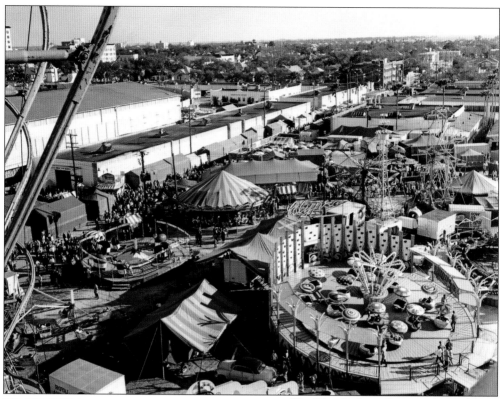

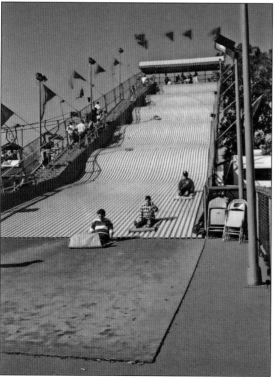

The Florida State Fair was first held in 1904 as the South Florida Fair and later the Mid-Winter Festival, before being known by its current name in 1915. The fair was originally held in conjunction with the annual Gasparilla parade, which ended at the fair when it was held at Plant Field near what is now the University of Tampa. This 1964 image shows the fair at its original downtown Tampa location. (Courtesy of the Florida State Archive.)

Over the years, the Florida State Fair outgrew its tight quarters at Plant Field. After being held at Tampa Stadium in 1976, the annual fair moved to its current, 330-acre location near the southwest corner of Interstate 4 and US Route 301 in East Tampa. This image shows a big yellow slide that has been a permanent landmark at the fairgrounds for decades. (Author's collection.)

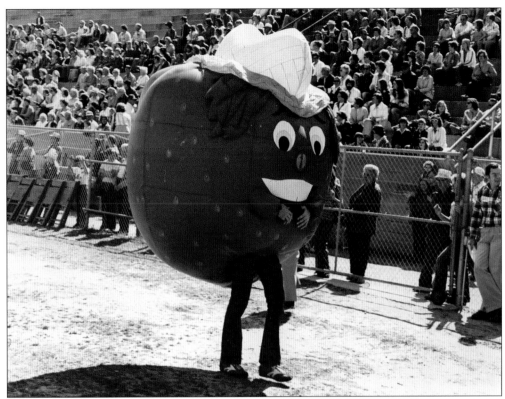

The Plant City Strawberry Festival has been an annual tradition since 1930, save for six years during and just after World War II. Founded by members of the Plant City Lions Club to pay homage to the community's bountiful strawberry fields, the annual festival has grown into a major regional event. The congenial strawberry ambassador in this 1970s image welcomes guests attending the fair. (Courtesy of the University of South Florida Library Special Collections Department.)

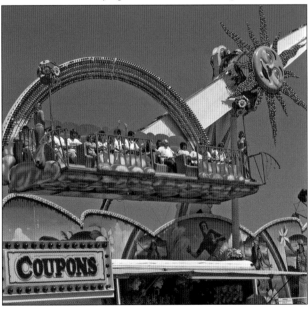

Dozens of thrilling rides such as this one light up the midway at the Plant City Strawberry Festival each year. It is estimated that about 500,000 people from central Florida and beyond attend the 11-day event each March. (Courtesy of the Florida State Archive.)

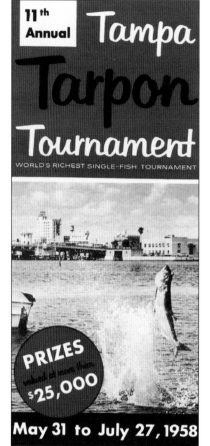

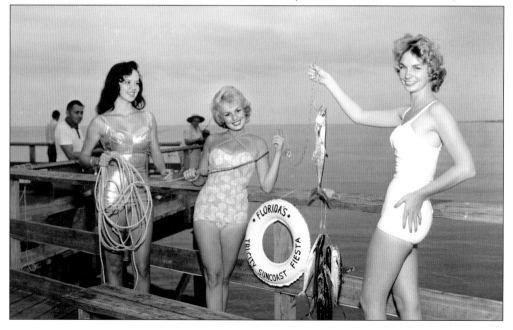

Anglers from around the bay area looked forward to the Tampa Tarpon Tournament, billing the highest prize anywhere in the world for a single fish. In 1958, the year this brochure was published, more than 3,000 anglers vied for prizes worth more than $25,000. The top prize that year was a new Chevrolet Brookwood station wagon with two-tone paint and V-8 engine. (Author's collection.)

These three attractive anglers are seen posing on the Indian Rocks fishing pier during the 1960 Tri-City Suncoast Fiesta. The summer-themed event was a collaborative effort of Tampa, St. Petersburg, and Clearwater, and it helped unify the region's tourism efforts. The event included a beauty pageant drawing young women from Hillsborough and Pinellas Counties, and the winner was crowned Miss Suncoast Fiesta. (Courtesy of the Florida State Archive.)

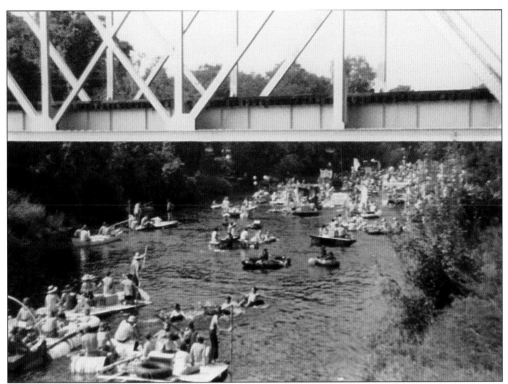

Thousands attended the Rambling Raft Race, an event hosted by the American Rafting Association during the late 1970s and early 1980s along the Hillsborough River. The annual race, which stretched 3.8 miles from Rowlett Park to the event's finish line at Lowry Park, was sponsored by Budweiser and Tampa's Q105-FM, among others. This photograph was taken near a CSX railroad bridge that parallels Rowlett Park Drive. (Author's collection.)

In 1979, the Bay Area Renaissance Festival was first held in Largo, the location where this photograph was taken in 1987. The annual event occurs in late winter and early spring and features archery contests, jugglers, costumed performers, food booths, jousting, and a human chess match. In 2004, the event relocated to a wooded site adjacent to the Museum of Science and Industry in Tampa. (Author's collection.)

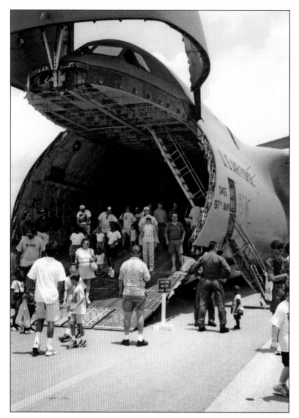

MacDill Air Force Base in Tampa hosts AirFest, an event that is usually held in the early spring of each year, with hiatuses during times of war or other extenuating circumstances. The weekend-long events play host to several flight demonstrations, shows by the US Air Force Thunderbirds, and hundreds of exhibits, including this 1970s Lockheed C-5A Galaxy awing crowds on the tarmac. (Author's collection.)

Tampa celebrated the centennial of the city's official founding in gala fashion during July 1987. Celebrations included bugle corps, hot air balloon displays, an antique car race, and a birthday cake shaped like the city's skyline, seen here. (Author's collection.)

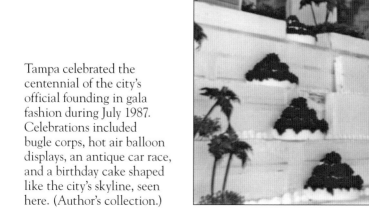

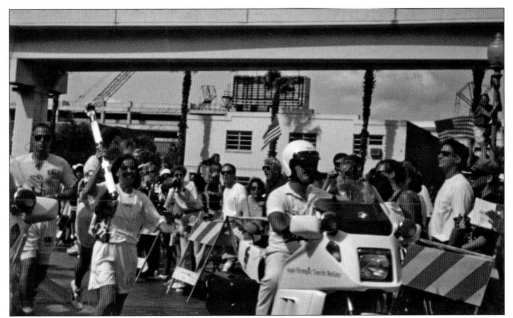

On July 3, 1996, the Olympic torch relay ran through Tampa en route to its eventual destination for the Summer Games in Atlanta, Georgia. This image shows the torch on its way toward Harbour Island. The Harbour Island People Mover automated tram shuttle system track and construction on the Ice Palace (now Amalie Arena) are seen in the background. (Author's collection.)

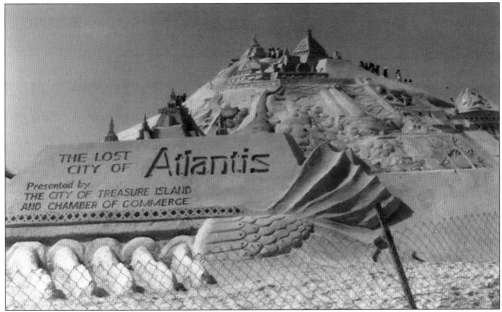

The Treasure Island Chamber of Commerce commissioned sand sculptor Todd Vander Pluym and his acclaimed Sand Sculptors International to construct what was once the world's biggest sand castle. The 37-foot-high structure took 12 days, 4,000 tons of sand, 12 workers, 500 volunteers, and 6 front-end loaders to complete. After it was finished on April 28, 1985, it drew some 150,000 sightseers during the first weekend alone and became a worldwide media sensation. The city has hosted many sand castle building events since. (Courtesy of Donna Skibo.)

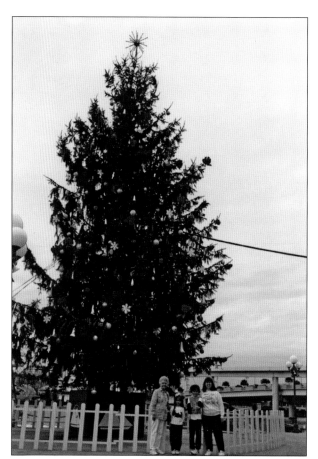

During the 1980s and 1990s, Harbour Island erected a real Christmas tree, touted as the largest in Tampa, for public display by the waterside. The first lighting of the tree each year would be joined by carols, a lighted boat parade, and other Christmas-themed festivities. (Author's collection.)

Epiphany Day, which is celebrated by orthodox Christians every January 6, has been held in Tarpon Springs since 1903. The religious ceremony includes joyous festivities culminating in the blessing of Spring Bayou, and a white cross is thrown in the water for boys aged 16 to 18 to retrieve—the diver who recovers it is said to be blessed for a year. (Courtesy of the University of South Florida Library Special Collections Department.)

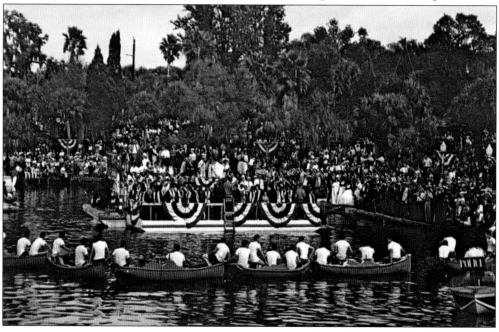

Three

HOTELS AND RESTAURANTS

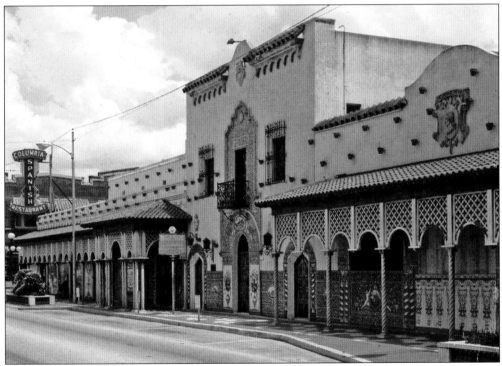

The Columbia Restaurant opened in Tampa's Ybor City in 1905. Founded by Casimiro Hernandez Sr., the Columbia had the first air-conditioned dining room in Tampa. The iconic landmark presents traditional Spanish flamenco dancing performances and serves up classic Latin dishes like paella (a seafood platter) and arroz con pollo (rice and chicken). The Columbia, located at 2117 East Seventh Avenue, is now the oldest continuously operating restaurant in Florida and one of the largest Spanish restaurants in the world. (Courtesy of the University of South Florida Library Special Collections Department.)

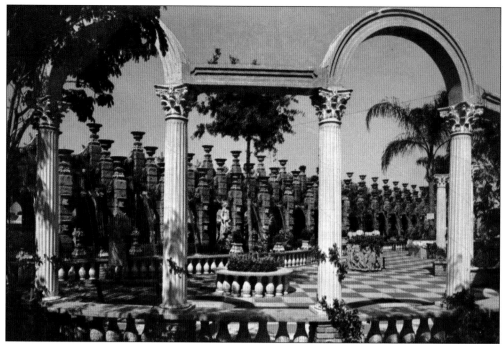

The Kapok Tree Inn was a grand restaurant in Clearwater that operated at 923 North McMullen Booth Road from 1957 through 1991. The landmark was known for its lavish landscaping, Roman-inspired fountains, and gaudy dining rooms. The restaurant was named for the large kapok tree nearby that had been a tourist attraction since many years earlier. Today, the building serves as a Sam Ash Music store, and much of the original décor and gardens remain. (Courtesy of the University of South Florida Library Special Collections Department.)

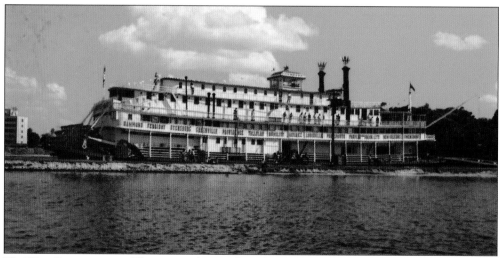

The *River Queen* was a paddle steamer that was launched in 1923 and conveyed passengers and cargo along the Ohio and Mississippi Rivers. Formerly named the *Cape Girardeau* and later the *Gordon C. Greene* and then *Sara Lee*, the *River Queen* was docked near Bradenton's Memorial Pier in 1957 and served as a restaurant and museum for almost three years before the ship was towed away. On December 3, 1967, the *River Queen* sank at her moorings in St. Louis. (Author's collection.)

Since 1956, Bern's Steak House at 1208 South Howard Avenue in Tampa has been a favorite among epicurean connoisseurs. Rated by television chef Rachael Ray as the best restaurant in America, Bern's offers the largest wine selection of any restaurant in the world and provides tours of its massive cellar to guests. (Courtesy of the Florida State Archive.)

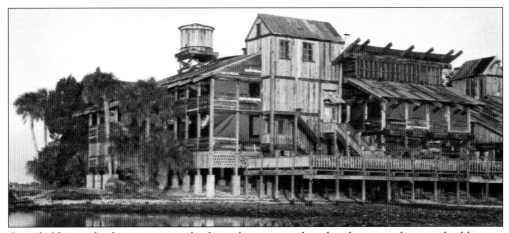

Crawdaddy's seafood restaurant and cabaret lounge stood in this distinctively rustic building on the south side of Rocky Point in Tampa. It was a popular restaurant from the 1970s through 1990s and was a favorite of tourists and locals alike. (Author's collection.)

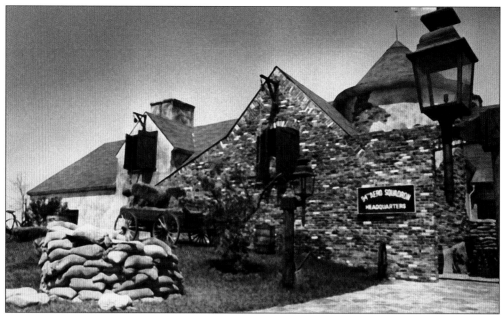

The 94th Aero Squadron restaurant was located adjacent to the St. Petersburg–Clearwater International Airport and served locals and tourists from March 1976 to June 2000. Known for its distinctive aviation theme, the 94th Aero Squadron restaurant paid homage to the United States Army Air Service unit that fought on the western front in World War I. Inside the restaurant's French farmhouse replica, diners would enjoy fine meals while taking in views of planes coming and going on the airport's runway. (Courtesy of the Clearwater Public Library System.)

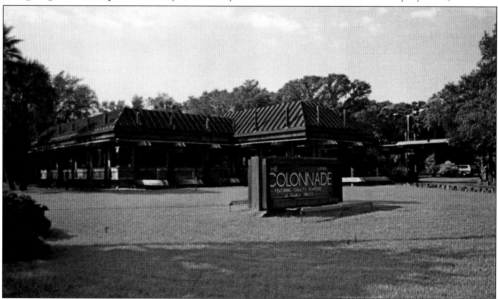

In 1935, the Colonnade opened on Bayshore Boulevard in Tampa and was originally noted for its hamburgers and fried chicken. Following World War II, the restaurant gained fame for its fresh seafood and remains popular to this day. This incarnation of the Colonnade at 3401 Bayshore Boulevard opened in 1974. (Courtesy of the University of South Florida Library Special Collections Department.)

In late 1977, Hudson Eugene Holloway opened the Sea Wolf Restaurant on the property formerly occupied by Treasureland. This ornate dining establishment served a wide range of fine cuisine and even hosted some of the biggest stars of the late 1970s and early 1980s. Seen here is the Teddy Roosevelt Lounge, just one of several distinct dining rooms at the opulent restaurant. (Courtesy of Hudson Eugene Holloway.)

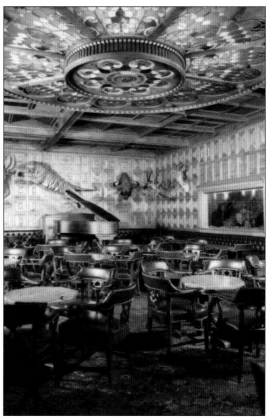

The View at CK's revolving restaurant offered diners exquisite 360-degree views atop the Marriott Hotel at Tampa International Airport. The restaurant, which featured a full bar and a broad menu of high-end dishes, opened in 1973 along with the hotel and witnessed countless people celebrate events ranging from proms to anniversaries before it closed in 2013. (Courtesy of the University of South Florida Library Special Collections Department.)

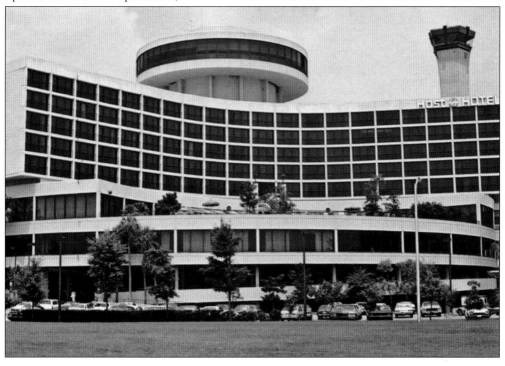

Greek immigrant Louis Pappas opened his first restaurant in 1925. Pappas's Greek salad was already legendary by the time the two-story Pappas Riverside Restaurant, seen here, opened at 10 Dodecanese Boulevard near the picturesque Anclote River in Tarpon Springs in 1975. The world-renowned restaurant closed in 2002, with the building reopening in 2010 as Riverside Grille House. (Courtesy of the University of South Florida Library Special Collections Department.)

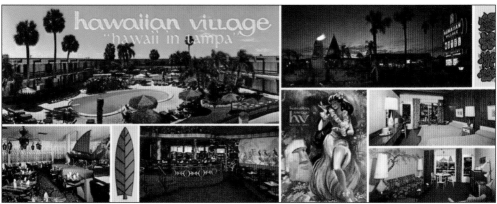

The 296-room Hawaiian Village motel was located at 2522 North Dale Mabry Highway. Billed as "Hawaii in Tampa," the popular motel featured two pools, convention and meeting facilities, and a restaurant offering Polynesian and Cantonese cuisine. Also, every room had a color television—a staple of the more luxurious roadside inns of the 1960s and 1970s. (Author's collection.)

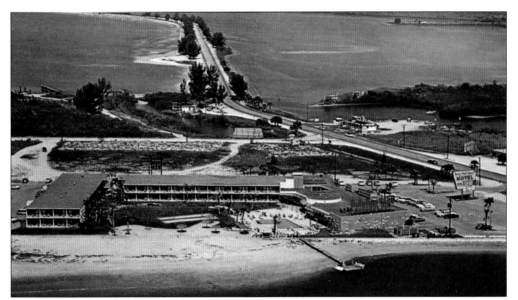

Rocky Point Beach Motel was located on the east end of the Courtney Campbell Causeway and offered 107 rooms, a cocktail lounge, and its own beach. There happens to be another "inn" in this image: the Mullet Inn Restaurant, a small white building seen in the mid-ground toward the right. The Mullet Inn Restaurant served seafood so fresh that the motto was "The fish we serve today slept last night in Tampa Bay." (Author's collection.)

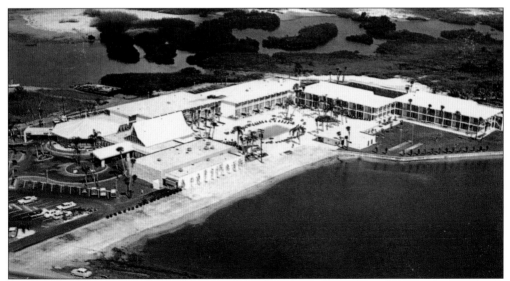

Across the street from Rocky Point Beach Motel was the Causeway Inn, offering 152 rooms, cabanas, and a conference center. The motel offered its own restaurant, televisions in every room, and great convenience for travelers visiting the bay area via Tampa International Airport, less than two miles to the east. (Author's collection.)

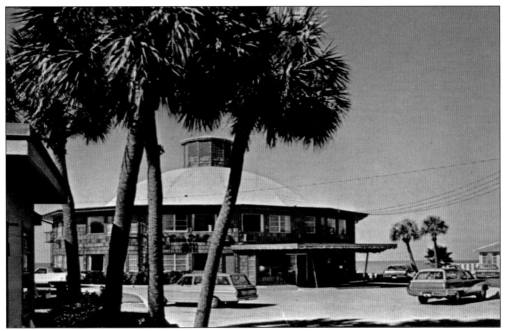

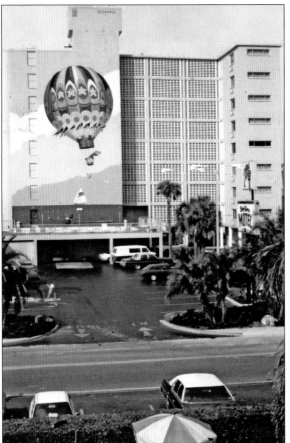

Sea Shell Hotel, located at 430 Mandalay Avenue in Clearwater, featured a distinctive architectural design, hotel rooms, and efficiencies. The hotel, quite popular with tourists in the 1950s and 1960s, was demolished in 1972 to make way for what is now the Hilton Clearwater Beach resort. (Author's collection.)

The nine-story, 64-room Spyglass Hotel opened along Clearwater Beach in 1971. For a few years, it was the tallest building on the beach. In November 1978, the motel became a canvas for artist Roger Bansemer, who painted a colorful mural of a hot air balloon being flown by a captain peering down from the basket with a sextant. An internationally televised implosion stunt by illusionist Criss Angel brought the hotel down in 2008. (Courtesy of Roger Bansemer.)

Beach Towers Apartment Motel on Clearwater Beach was located just steps north of the Spyglass Hotel and offered sweeping vistas of the beach. The now-demolished motel, which saw its heyday in the 1960s and 1970s, gained landmark status largely due to its two striking Googie-style cupolas. (Author's collection.)

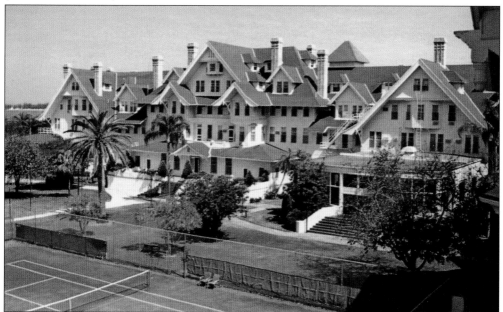

The Belleview-Biltmore Hotel was built by Henry B. Plant in 1897 and bolstered tourist ridership on his railroad system serving the west coast of Florida. The grand hotel hosted many celebrities and was a popular tourist destination into the 1960s. The aging Queen Anne hotel was added to the National Register of Historic Places on December 26, 1979, and closed in 2009. (Courtesy of the University of South Florida Library Special Collections Department.)

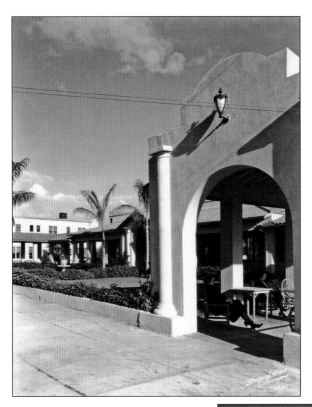

Safety Harbor Resort and Spa was built on the site of the Espiritu Santo Springs (or Springs of the Holy Spirit), a name given by Spanish explorer Hernando de Soto in 1539 when he was seeking the Fountain of Youth years after Juan Ponce de León set out to find the fabled font. The site, which opened as a spa at 105 North Bayshore Drive in 1925, was designated as a National Historic Landmark by the US Department of the Interior in 1964 and a Florida Heritage Landmark in 1997. (Courtesy of the Tampa-Hillsborough Public Library.)

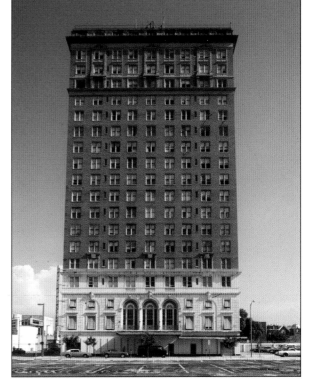

Located at 905 North Florida Avenue in downtown Tampa, the Floridan Hotel was once the tallest building in Florida and considered one of the finest hotels in the state when it opened in 1927. Amid declining popularity, the hotel closed in 1966 to commercial and tourist guests, and the rooms were rented on a long-term basis. The Floridan closed in 1989, and the building was purchased in 2005. The structure reopened as the Floridian Palace Hotel in 2012 following a seven-year restoration project. (Courtesy of the University of South Florida Library Special Collections Department.)

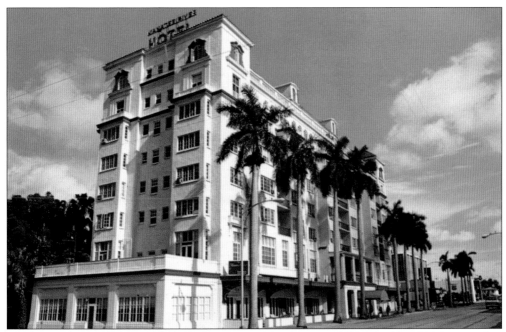

The ritzy Manatee River Hotel, dubbed "Queen of the West Coast," opened in 1926. It catered to movers and shakers such as Babe Ruth, Clark Gable, Greta Garbo, and Al Capone. The building became a senior housing facility soon after its closing in 1966 and served in that capacity for decades. After a series of transactions in the first decade of the 2000s, the landmark at 309 Tenth Street West became a Hampton Inn in 2013. (Courtesy of the University of South Florida Library Special Collections Department.)

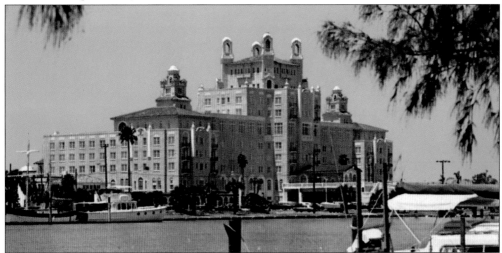

Opened in 1928, the Don CeSar Hotel has long served the rich and famous. The popular St. Pete Beach retreat, dubbed "the Pink Lady," fell into a state of disrepair following the owner's death in 1940. It served as a military hospital during World War II, then a regional office for the Veterans Administration. A Holiday Inn franchise owner purchased the building, which reopened under the Don CeSar name in 1973. It was soon added to the National Register of Historic Places and underwent a series of renovations in the decades that followed. (Courtesy of the University of South Florida Library Special Collections Department.)

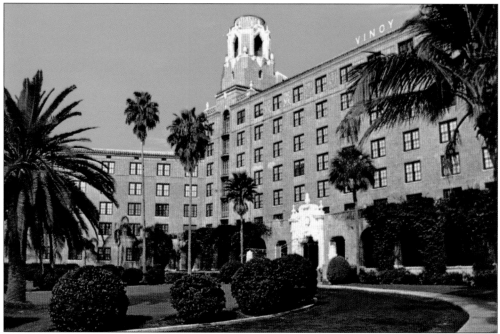

The Vinoy Park Hotel opened in 1925 and was a popular destination for notables such as James Stewart and Babe Ruth and presidents Herbert Hoover and Calvin Coolidge. The Vinoy closed in 1974 and fell into disrepair, but it reopened in the 1990s following a $93 million renovation and is once again among the finest hotels in the region. (Courtesy of the University of South Florida Library Special Collections Department.)

The 177-acre island immediately south of downtown Tampa was originally called Seddon Island and built to accommodate a port. In 1979, the land was sold to Beneficial Land Corporation for residential, office, and retail development, which culminated with the debut of Harbour Island in 1985. A Westin hotel operates in the tall building standing prominently in this photograph. (Courtesy of the Florida State Archive.)

Four

PARKS AND RECREATION

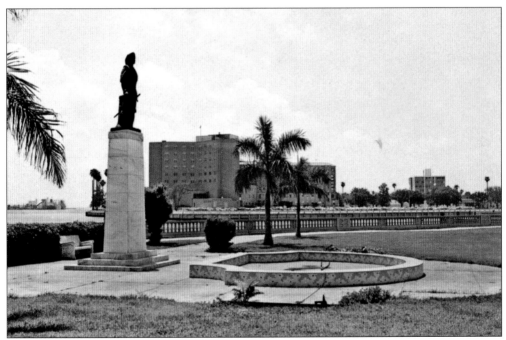

This 1960s image shows Columbus Statue Park, measuring half an acre in size and marking the northern terminus of the Bayshore Boulevard sidewalk and linear park in Tampa. A statue of famed explorer Christopher Columbus stands in the foreground, while Tampa General Hospital is seen in the background. (Courtesy of the University of South Florida Library Special Collections Department.)

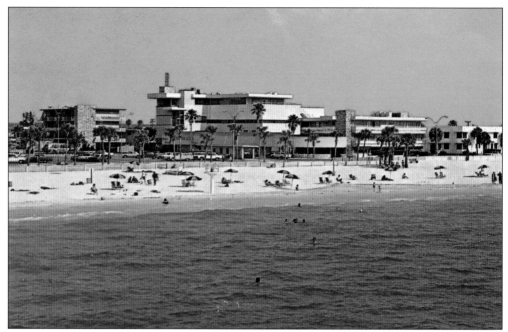

This mid-1960s photograph shows Clearwater Beach just south of Pier 60. On the left is the Port Vue; the Candlelight Inn is the prominent hotel in the center. High-rise hotels would begin overwhelming the Clearwater Beach skyline in the 1970s. (Author's collection.)

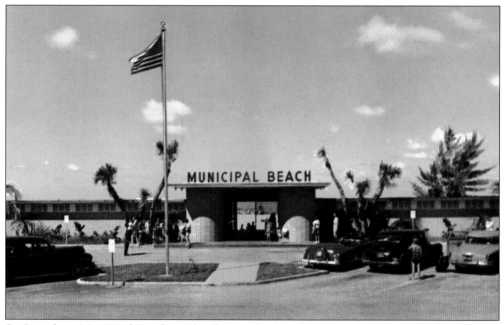

St. Petersburg Municipal Beach is a lovely stretch of public access beach along Gulf Boulevard near 112th Avenue adjacent to Treasure Island. (Courtesy of the University of South Florida Library Special Collections Department.)

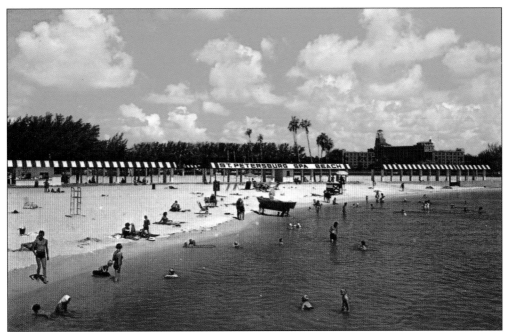

Spa Beach is a public park along the approach of the pier near downtown St. Petersburg. In the background of this 1960s photograph is the Vinoy Hotel. (Author's collection.)

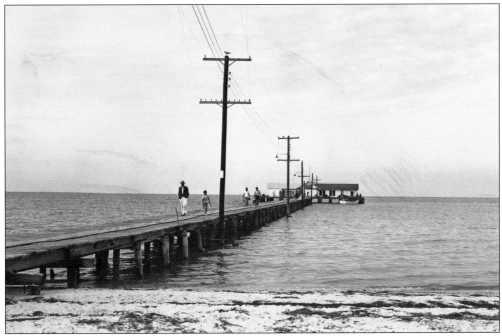

The Anna Maria Island City Pier, seen here in the 1950s, extends 700 feet from the beachfront along South Bay Boulevard into the waters of southern Tampa Bay. The City Pier opened in 1910 and has served generations of locals and tourists. (Courtesy of the Florida State Archive.)

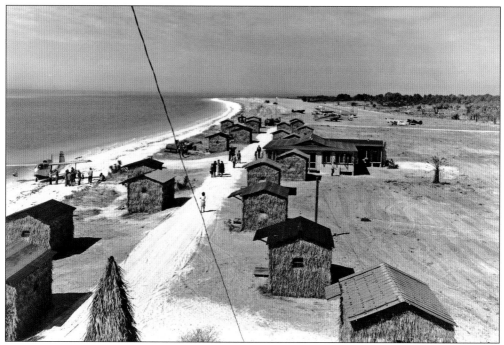

Honeymoon Island and Caladesi Island were once part of a large barrier island that was cut in two by a major 1921 hurricane. By the 1940s, Honeymoon Island, originally called Hog Island, gained nationwide fame as a remote retreat for newlyweds. A causeway that links Honeymoon Island to the mainland was built in 1964. The huts pictured here were demolished when the land became a state park. (Courtesy of the Tampa-Hillsborough Public Library.)

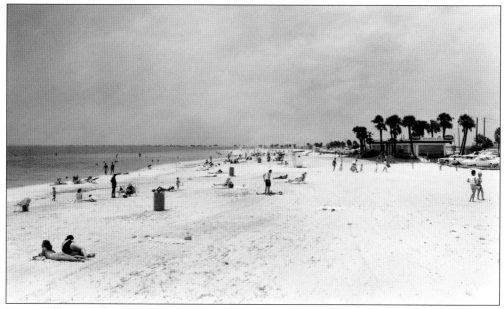

Tampa offers a few beaches of its own, including Ben T. Davis Beach, seen here in 1965. Ben T. Davis Beach is located on the Tampa side of the Courtney Campbell Causeway, along the western edge of Rocky Point. (Courtesy of the Florida State Archive.)

In 1849, Bvt. Col. Robert E. Lee, who would later become a famous Civil War commander, and three other US Army engineers recommended military fortification on Mullet and Egmont Keys. The fort, built for the Spanish-American War in 1898 but finished after the conflict ended, was named for Spanish explorer Hernando de Soto in 1900. The land was used as a bombing range during World War II, and the five interconnected keys were purchased by Pinellas County in 1948. The land was established as Fort De Soto Park in 1962. (Author's collection.)

Fort De Soto Park offers many amenities. These include a restaurant, pavilion, and souvenir shop, seen here in the 1960s. (Courtesy of the University of South Florida Library Special Collections Department.)

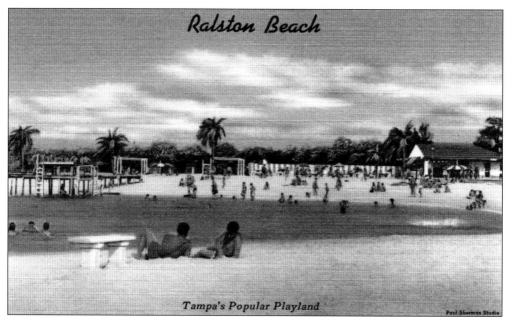

Ralston Beach and Colonial Beach were two popular gathering places on Egypt Lake in Tampa during the 1950s and 1960s. Ralston was situated on the southeast side of the lake, and Colonial resided on the southwest shore. Both beaches featured picnic areas and bathhouses. Colonial Beach also offered a pavilion (below), where dances and concerts were held. Tampa Ski Bees water-skiers utilized Egypt Lake as a practice site during the time that Colonial and Ralston Beaches were operating and would put on free performances for beachgoers. By the 1970s, development on the lake took over the two popular weekend getaways, and the sites are now home to residential communities. (Both, author's collection.)

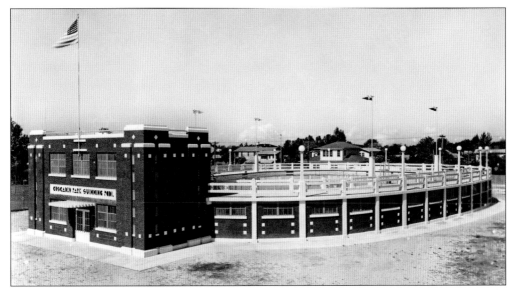

In 1937, the Cuscaden Park pool was built along Fifteenth Street in Ybor City by the Works Progress Administration, and it remained open until leaks were discovered in 1997. Following repairs, the pool briefly reopened until leaks and cracks resurfaced. The pool's future remains murky. (Courtesy of the Tampa-Hillsborough Public Library.)

The 160-acre Lithia Springs Regional Park is located on the Alafia River and features a natural spring that remains 72 degrees in temperature year-round. The park also offers a bathhouse, playground, picnic facility, and campgrounds. (Courtesy of the Tampa-Hillsborough Public Library.)

Philippe Park, in Safety Harbor, is the oldest park in Pinellas County and named for Count Odet Philippe, who introduced grapefruit to Florida in 1823. The 122-acre park lies on land that was part of his plantation and includes a Tocobaga Indian mound that is listed in the National Register of Historic Places. (Author's collection.)

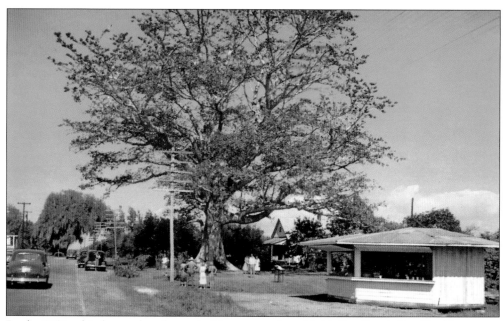

By the 1950s, this famous kapok tree in Clearwater along McMullen Booth Road had become a popular roadside attraction. This exotic tree, grown from a species transplanted from India in the 19th century, inspired the adjacent namesake Kapok Tree Inn restaurant, established by Richard B. Baumgardner and Jim Jones in 1957. (Author's collection.)

Hillsborough River State Park, one of the eight original state parks established in Florida in 1938, straddles the picturesque Hillsborough River in Thonotosassa. The park offers picnicking, camping, and swimming. Small rapids along the river pose a pleasant challenge to those in canoes and kayaks, and the park's rugged trails are ideal for hikers and bikers. (Courtesy of the University of South Florida Library Special Collections Department.)

Keystone Lake is a 431-acre spring-fed lake in northwest Hillsborough County. In the middle of the 20th century, when the surrounding Odessa area was still mainly occupied by orange groves and other agricultural activities, small cottages were built around the lake, and the area became a popular recreational spot for boaters and anglers. (Courtesy of the Tampa-Hillsborough Public Library.)

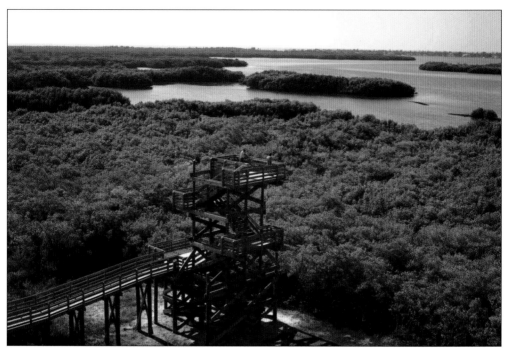

Weedon Island Preserve is a Native American archeological site with more than four miles of nature paths, canoe and kayak trails, a 3,000-foot boardwalk, and a 45-foot observation tower. The park, which is located just north of St. Petersburg, was added to the National Register of Historic Places on June 13, 1972. (Courtesy of the City of St. Petersburg.)

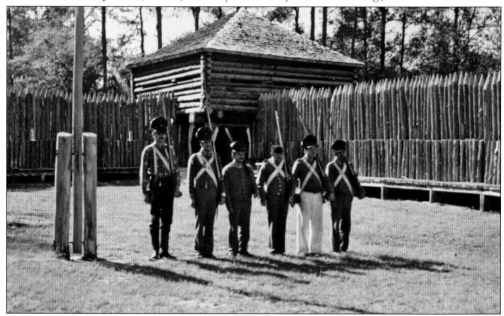

Fort Foster is part of Hillsborough River State Park and features a reconstructed fort from the Second Seminole War. The fort was established in 1836, saw battle in 1837, and was reactivated when needed throughout the 1840s. The fort was added to the National Register of Historic Places on June 13, 1972. (Courtesy of the University of South Florida Library Special Collections Department.)

De Soto National Memorial honors Spanish explorer Hernando de Soto and his four-year, 4,000-mile expedition to Florida. Located at the northern end of Seventy-fifth Street NW in Bradenton, the park allows visitors to walk nature trails, try on armor, and explore coastal landscape as seen by the conquistadors in the 16th century. (Courtesy of the University of South Florida Library Special Collections Department.)

Tampa Electric's Big Bend Power Station in Apollo Beach is the site of the Manatee Viewing Center, which opened in December 1986. Local manatees seek safe harbor in the power station's clean, warm discharge canal, which is a federally designated manatee sanctuary. Manatees are found there in the greatest numbers during the winter, when the open water of the bay cools below 68 degrees. (Author's collection.)

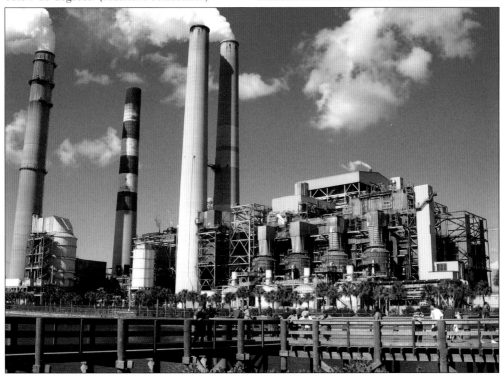

In the mid-1950s, Mennonite preacher Lawrence Brunk settled land in Ellenton that would eventually become Victory Camp. The Christian retreat was located just off US 301 and included a chapel, hotel, classrooms, dormitory, dining hall, and a mobile home park. Today, the site belongs to Colony Cove, a 2,200-unit mobile home park. One of Victory Camp's original buildings, Friendship Hall, serves as a community building. (Courtesy of the University of South Florida Library Special Collections Department.)

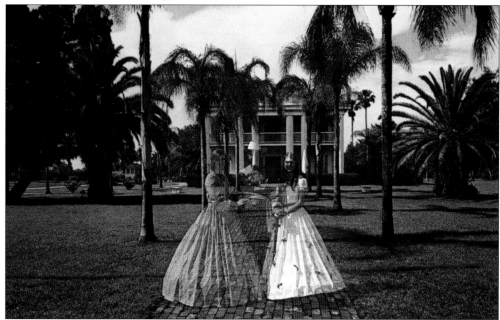

The Gamble Mansion was once owned by Maj. Robert Gamble and was the headquarters of a large sugar plantation that once occupied 3,500 acres. The Gamble Mansion was built around 1850 and is South Florida's last surviving antebellum plantation house. The home was placed in the National Register of Historic Places in 1970 and is open to the public at Gamble Plantation Historic State Park in Ellenton. (Courtesy of the University of South Florida Library Special Collections Department.)

Five

SHOPPING AND ENTERTAINMENT

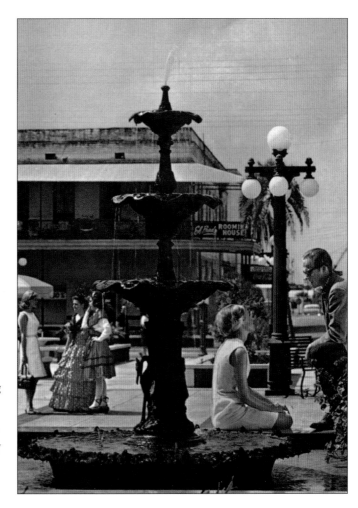

This 1970s image of Ybor City exemplifies the neighborhood's long-standing reputation as a historic shopping and entertainment hub. Today, thousands of locals and tourists can be seen strolling Seventh Avenue and other strips in the city's Latin Quarter on any given Friday or Saturday night. (Courtesy of the University of South Florida Library Special Collections Department.)

The town of Dunedin formed in 1899 and was incorporated as a city in 1925. Many of the buildings seen here along Main Street in this early 1980s photograph date from the first decades of the 20th century and now house shops, boutiques, cafés, and other small businesses frequented by hundreds of locals and tourists each week. Since 1990, the nearby Dunedin Stadium (now Florida Auto Exchange Stadium) has hosted spring training games for the major-league baseball Toronto Blue Jays and home games for the Dunedin Blue Jays minor-league team. (Courtesy of the City of Dunedin.)

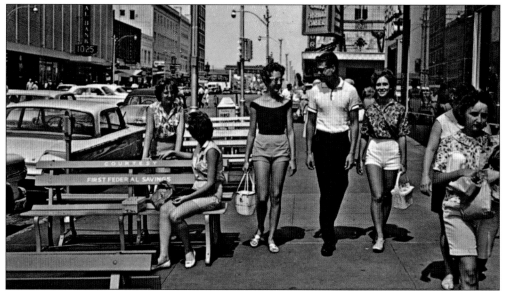

Downtown St. Petersburg, seen here in the 1960s, has always had a vibrant city life. For much of the 20th century, the city was widely known for its green benches and retiree population. However, the brightly colored benches and shoppers of all ages in this image symbolically foretell the vivid nature that would emerge in the city in later years. (Courtesy of the University of South Florida Library Special Collections Department.)

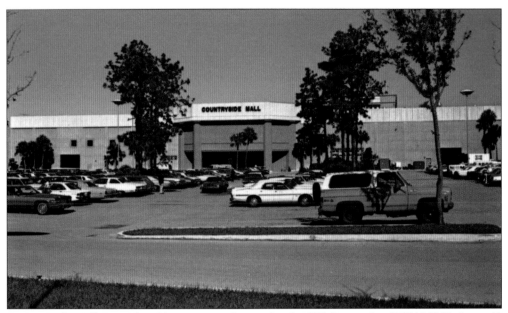

Countryside Mall opened in Clearwater on September 8, 1975. Situated at 27001 US Highway 19 North, the mall opened with anchors Maas Brothers and Sears, and within a year JCPenney and Robinson's would also appear. A distinctive feature at the mall is an ice rink, located near the center of the two-story, 1.2-million-square-foot retail hub. Westfield Group acquired the property in 2002 and completed a massive renovation of the mall in 2009. (Courtesy of the University of South Florida Library Special Collections Department.)

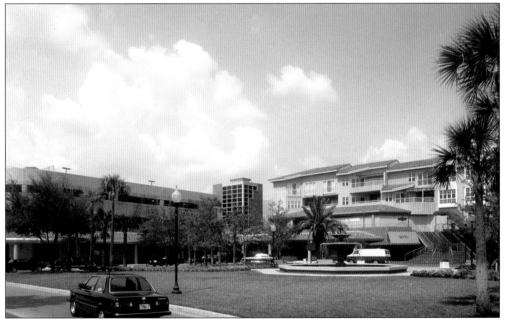

Hyde Park Village is an upscale open-air shopping plaza located at 1602 West Snow Circle in South Tampa. This image was taken during the late 1980s, when Hyde Park Village was anchored by Jacobson's department store. (Courtesy of the University of South Florida Library Special Collections Department.)

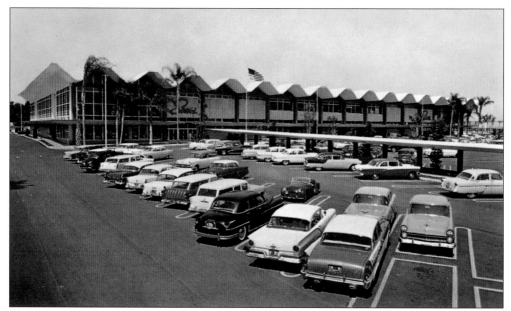

This Sears department store opened at 2010 East Hillsborough Avenue in 1957 and was a popular shopping destination in Tampa for many years. By 1975, a Sears store had opened at the new University Square Mall on Fowler Avenue near the University of South Florida. This building was soon turned over to the Hillsborough County School Board, which opened David G. Erwin Technical Center here in 1980. (Author's collection.)

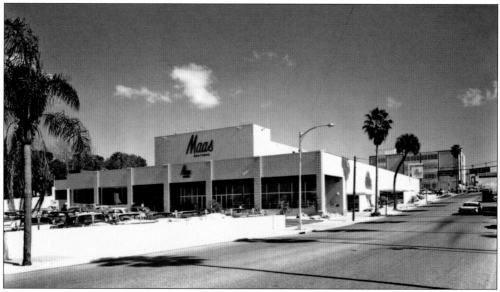

Maas Brothers is in iconic name in Tampa retail history. In 1886, the first Maas Brothers department store was founded in downtown Tampa by two German brothers named Abe and Isaac Maas. The chain grew to 39 stores before going defunct in 1991. Former Maas Brothers stores were converted to Burdines, which would later be taken over by Macy's. This store in downtown Clearwater would become the Harborview Center in 1994 and by 2011 served as Winter's Dolphin Tale Adventure, a children's museum showing props and scenery from the locally filmed major motion picture *Dolphin Tale*. (Courtesy of the Tampa-Hillsborough Public Library.)

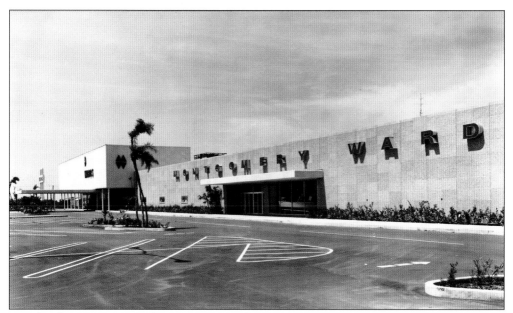

Another bygone name in department store history, Montgomery Ward operated this store at 1701 North Dale Mabry Highway during the 1960s and 1970s. Montgomery Ward moved into nearby Tampa Bay Center in 1980, and this site is now the home of Walmart and Best Buy stores. (Courtesy of the Tampa-Hillsborough Public Library.)

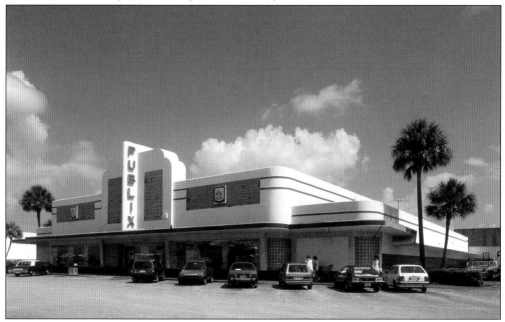

Publix is a grocer that generations of shoppers in the Tampa Bay area have trusted. Many of Publix's earlier grocery stores, the first of which opened in 1930, featured Art Deco facades. This now-demolished store at 3615 Gandy Boulevard in South Tampa was built in 1954 and is a typical representation of the distinctive post–World War II Publix stores that sprang up around the bay area. A much larger Publix stands at this site today. (Courtesy of the University of South Florida Library Special Collections Department.)

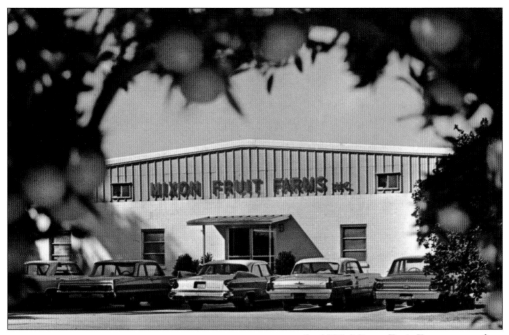

In 1939, Mixon Fruit Farms started on 20 acres with a small stand in front of the family's house, and it soon became one of the first gift-fruit shippers in Florida. Today, Mixon Fruit Farms, located at 2525 Twenty-seventh Street East in Bradenton, offers tram tours, homemade treats, and concerts. (Courtesy of the University of South Florida Library Special Collections Department.)

Tampa Bay Center opened on August 5, 1976, across from Tampa Stadium at the southeast corner of Himes Avenue and Buffalo Avenue (now Dr. Martin Luther King Jr. Boulevard). Tampa Bay Center became Tampa's fourth major mall, following Westshore Plaza (1967), Floriland Mall (1972), and University Square Mall (1974). The two-story Tampa Bay Center closed in 2001, and many of its tenants moved into Citrus Park Mall and International Plaza. The mall property is now the site of the Tampa Bay Buccaneers' training facility. (Courtesy of Dan Perez.)

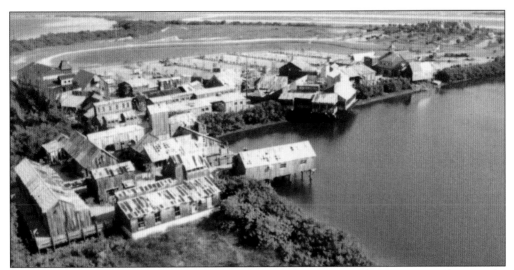

Boatyard Village shopping center and the adjacent 94th Aero Squadron restaurant (upper-right corner) served up fun for locals and tourists throughout the 1980s. The complex was located near the St. Petersburg–Clearwater Airport in the Highpoint community. While a popular destination, the shopping and entertainment hub was located on a rather secluded spot at 16100 Fairchild Drive and would fall on hard times during the 1990s, subsequently closing. (Author's collection.)

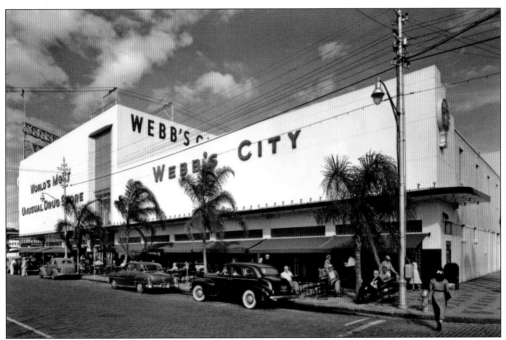

Webb's City was a one-stop department store that was dubbed "the World's Most Unusual Drug Store." Indeed, it was unusual—at one time, it spanned seven city blocks in downtown St. Petersburg. There was an Arthur Murray dance studio on the roof, performances by chimpanzees and baseball-playing ducks, and merchandise from coffee grounds to furniture. The unique attraction, which opened in 1926, closed on August 18, 1979. (Courtesy of the Tampa-Hillsborough Public Library.)

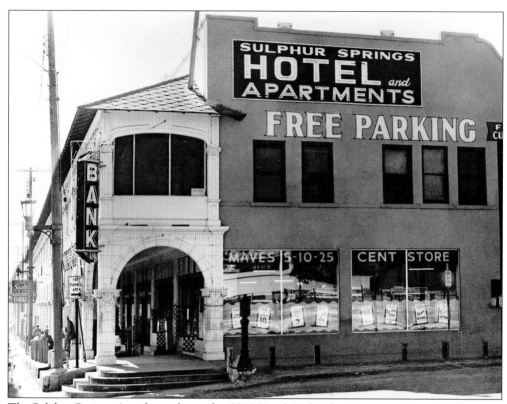

The Sulphur Springs Arcade was located at 8300 North Nebraska Avenue in Tampa and listed as the nation's first miniature mall by Ripley's Believe It or Not! The Mediterranean-style shopping center was operating by 1927 and housed a bakery, pool hall, barbershop, jeweler, liquor store, grocery, furniture store, appliance store, jailhouse, five-and-dime store, a post office, bank, and two pharmacies. The second floor had 39 motel rooms, 14 apartments, and office space. The arcade was demolished to expand parking for the nearby greyhound track in 1976. (Courtesy of the Cinchett collection.)

Robert's Christmas Wonderland in Clearwater originated in 1972. Robert's was once a seasonal store called Robert's Christmas World located in Pinellas Park. Another store at the current location at 2951 Gulf to Bay Boulevard called Christmas Wonderland sold aboveground pools in the summer. The two stores merged in 1990 and focused on selling Christmas goods year-round, and it is now one of the largest stores dedicated to selling Christmas merchandise. (Author's collection.)

Haslam's Bookstore was founded by John and Mary Haslam in 1933, during the throes of the Great Depression. The store has moved four times as it has grown and now offers more than 300,000 books of all kinds over 30,000 square feet at its 2025 Central Avenue location, earning the St. Petersburg institution the distinction of being Florida's largest new and used bookstore. (Courtesy of Haslam's Bookstore.)

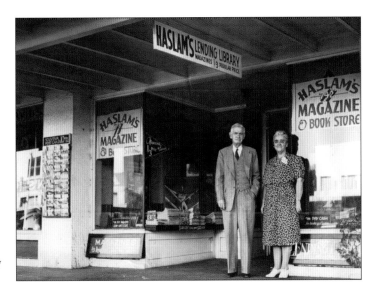

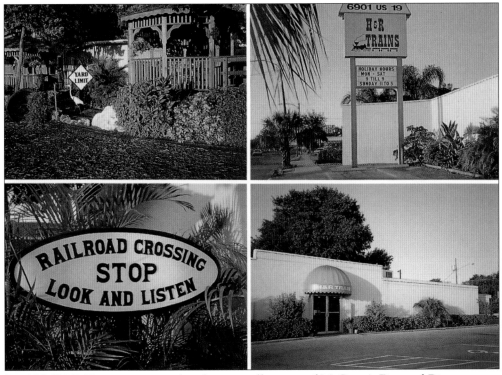

In 1976, H&R Trains was started within a small corner of McCrory's Five-and-Dime store at Gateway Mall in St. Petersburg. The inventory sold out quickly, and crowds grew large. The store, engineered by Don and Alice Morris, eventually moved to a one-acre site at 6901 US Highway 19 in Pinellas Park. The store has sold a full range of merchandise to thousands of model train enthusiasts, including Hollywood's Burt Reynolds, Sally Jesse Raphael, and Gary Coleman. (Courtesy of H&R Trains.)

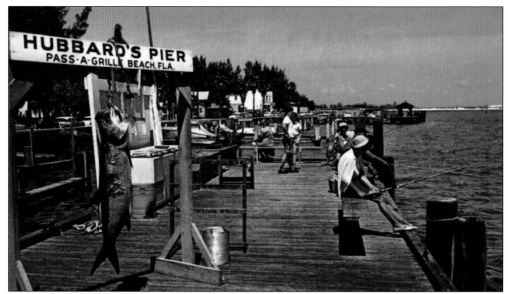

In the 1950s, William Hubbard established the first Gulf Coast half-day fishing party boat tour, expanding to weekend-long fishing trips by the early 1970s. The Eighth Avenue Pier in Pass-a-Grille was soon known as Hubbard's Pier. In 1976, Hubbard moved his operations to John's Pass, and by 1979 he opened the Friendly Fisherman Seafood Restaurant, which serves fresh seafood and catches made by the anglers themselves. (Courtesy of the University of South Florida Library Special Collections Department.)

Tarpon Springs, boasting the highest percentage of Greek Americans in any US city, is famous for its sponge industry. Greek immigrants arrived during the 1880s, and in 1905, John Cocoris brought sponge divers from Greece's Dodecanese Islands who would help build the foundation of the thriving sponge-diving operations that continue to this day. This 1960s image shows the world-famous sponge dock, where locals and tourists alike can still purchase freshly retrieved sponges and other goods. (Courtesy of the University of South Florida Library Special Collections Department.)

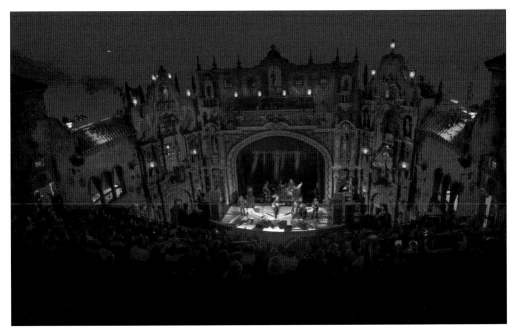

The Tampa Theatre at 711 North Franklin Street opened on October 15, 1926, and debuted at a time when 10¢ bought two hours of escape into a realm of fantasy and opulence. The theater's popularity waned in the 1960s, but it was spared from the wrecking ball in the 1970s. Added to the National Register of Historic Places in 1978, the theater continues to charm audiences with its old-world architecture, dazzling decor, and a "Mighty Wurlitzer" organ. (Courtesy of the Tampa Theatre.)

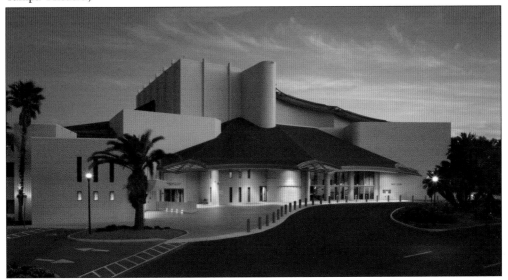

Named for the wife of drugstore magnate Jack Eckerd, Ruth Eckerd Hall at 1111 North McMullen Booth Road was dedicated on October 15, 1983. Built on a 38-acre tract in Clearwater that was donated by the Kapok Tree Corporation, Ruth Eckerd Hall is a world-class performance hall featuring architectural cues reminiscent of Frank Lloyd Wright's designs. Ruth Eckerd Hall stages events ranging from concerts to Broadway productions and hosts more than 350,000 audience members each year. (Courtesy of Ruth Eckerd Hall.)

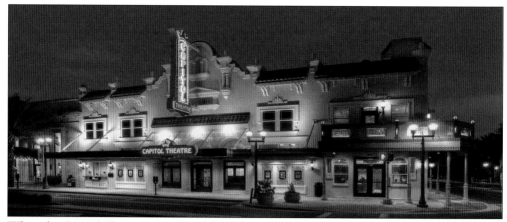

When the Capitol Theatre opened on March 31, 1921, it was described by the *Clearwater News* as "one of the most beautifully finished playhouses in the South." Movies and vaudeville acts were the principal attractions during the theater's early years, and its Mediterranean Revival facade, arched entrances, and other ornate architectural elements awed locals and tourists alike. The theater at 405 Cleveland Street in Clearwater has undergone renovations and now offers 750 seats, six private loge boxes, numerous concession stands, and a VIP room, among many other features. (Courtesy of Creative Contractors, Inc.)

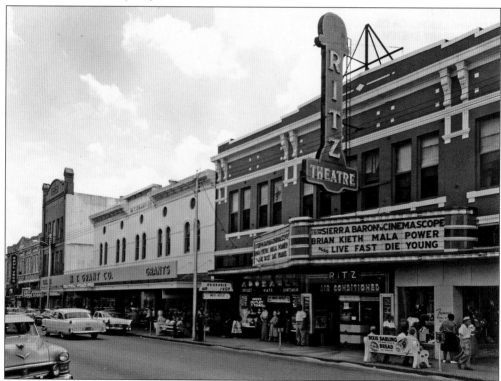

The Rivoli Theatre in Ybor City opened in 1917. During the 1930s, it was expanded and became the Ritz Theatre. The venue at 1503 East Seventh Avenue closed as a movie theater in 1982 and a decade later became the Masquerade concert hall and nightclub, which closed in 2006. Reopening as the Ritz Theatre in June 2008, the performance hall now hosts concerts and other events. (Courtesy of the Tampa-Hillsborough Public Library.)

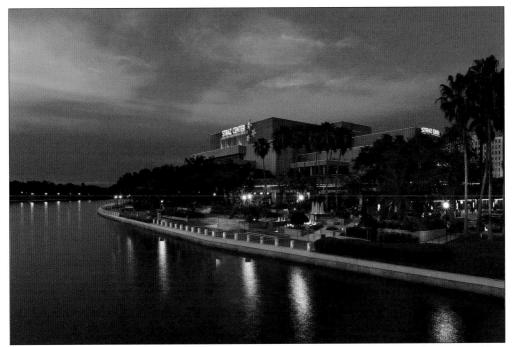

The David A. Straz Jr. Center for the Performing Arts opened its doors in July 1987 and has welcomed more than 10 million guests. The 335,000-square-foot facility was originally named the Tampa Bay Performing Arts Center and provides an environment for a wide variety of world-class events, including one of the nation's leading Broadway series. (Courtesy of the David A. Straz Jr. Center for the Performing Arts.)

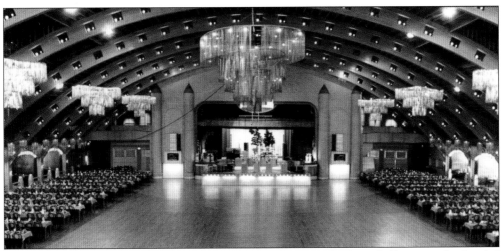

The Coliseum in downtown St. Petersburg opened in 1924 as "the finest ballroom in the South," and it was purchased by the City of St. Petersburg in 1989. The facility, at 535 Fourth Avenue North, has undergone major renovations over the years and hosts a wide range of events each year. (Courtesy of the Tampa-Hillsborough Public Library.)

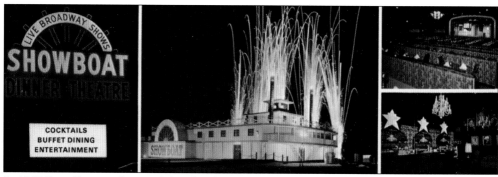

In 1967, Dow Sherwood opened the Showboat Dinner Theatre at 3405 Ulmerton Road in Pinellas Park. The theater hosted stars such as Ann B. Davis, Don Ameche, Joan Caulfield, and Pat O'Brien and offered performances most nights each week. The Showboat Theater closed in 1995 and was demolished to make way for a restaurant, gas station, and hotel. (Author's collection.)

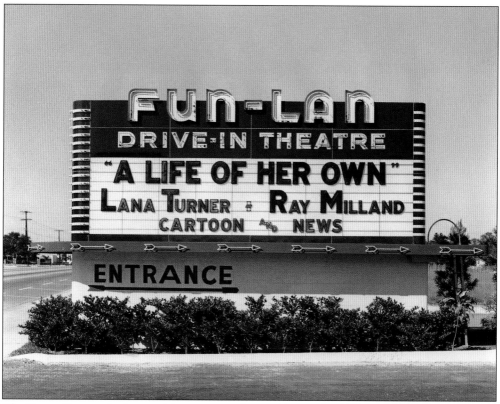

The Tampa Bay area had many drive-in movie theaters during the 1950s and 1960s. In Bradenton, there was Suburban Drive-In; St. Petersburg had Fourth Street Drive-In, Garden Drive-In, and Twenty-eighth Street Drive-In; Clearwater offered Gulf to Bay Drive-In and Ulmerton Drive-In; Largo fielded Thunderbird Drive-In; Tampa hosted Dale Mabry 20th Century Drive-In, Hillsboro Drive-In, Tower Drive-In, Floriland Drive-In, and others. Today, Funlan Drive-In at 2302 East Hillsborough Avenue in Tampa continues to entertain moviegoers as it has since 1950. (Courtesy of the Tampa-Hillsborough Public Library.)

Six

ART, LANDMARKS &
TRANSPORTATION

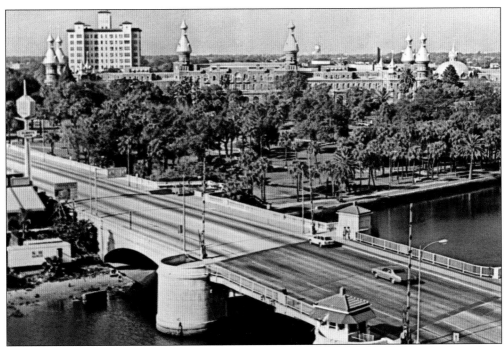

The Lafayette Street Bridge was dedicated on February 23, 1914. This historic bridge, which crosses the Hillsborough River just west of downtown Tampa, has undergone many repairs and upgrades over the years but generally maintains its original appearance. This 1960s image shows the University of Tampa in the background. (Courtesy of the University of South Florida Library Special Collections Department.)

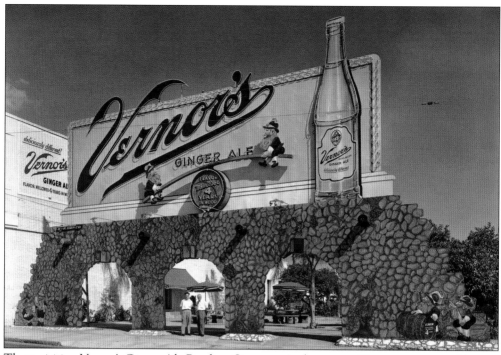

Those visiting Vernor's Ginger Ale Bottling Company in downtown Tampa were greeted by two gnomes teeter-tottering on the company's sign, which measured 32 feet high and 70 feet long and was touted as the largest animated signboard in the Southeast. The factory was located at 211 East Platt Street (now Channelside Drive) on the site where the Tampa Convention Center now stands. (Courtesy of the Tampa-Hillsborough Public Library.)

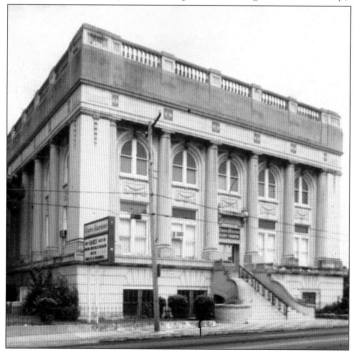

In 1914, Centro Asturiano de Tampa was built for $110,000 and primarily served Ybor City's Latin cigar factory workers. Centro Asturiano had a gymnasium, billiard room, library, auditorium, three-lane bowling alley, a grand ballroom, and a large cantina. The building, at 1913 North Nebraska Avenue, has been listed in the National Register of Historic Places since 1974 and hosts many special events each year. (Courtesy of the University of South Florida Library Special Collections Department.)

Bayshore Boulevard is located south of downtown Tampa and provides scenic views of Hillsborough Bay in South Tampa. In addition to its amazing views, Bayshore Boulevard's main claim to fame is its sidewalk, which is 4.5 miles in length and the longest continuous sidewalk in the world. The exquisite promenade would be repaved and significantly upgraded as a Works Progress Administration project in the 1930s. (Courtesy of the University of South Florida Library Special Collections Department.)

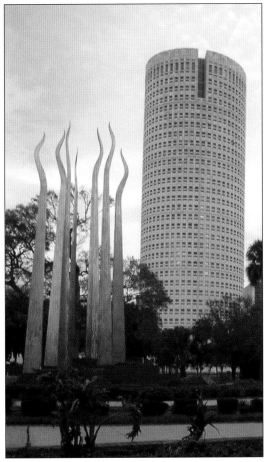

This sculpture in Plant Park at the University of Tampa is called *Sticks of Fire*, which is widely believed to be what the name Tampa means in the Calusa language. The name is thought to refer to the high concentration of lightning strikes in the area during the summer months or a place to gather campfire wood. The round Rivergate Tower, which was completed in 1988 and often referred to locally as "The Beercan Building," stands 454 feet tall in the background. (Courtesy of the Florida State Archive.)

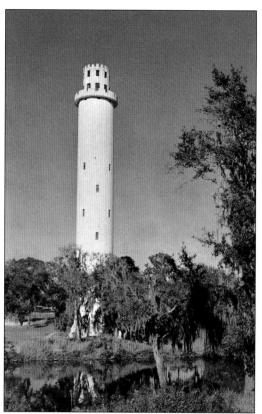

The Sulphur Springs Water Tower stands 214 feet tall on the Hillsborough River near the intersection of Florida Avenue and Bird Street in Tampa. The water tower was built in 1927 by Grover Poole for Sulphur Springs developer Josiah S. Richardson. The tower provided water to homes and businesses throughout the immediate vicinity until 1971, when Tampa's water department took over. Following years of disrepair, the tower was restored in 1989. (Author's collection.)

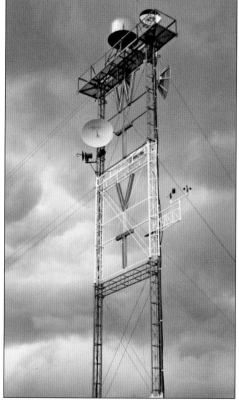

This "Twin Tower" sign stood in front of the WTVT-13 television station on Kennedy Boulevard from the 1960s into the late 1980s, when the facility was rebuilt. The television station now has the Roy Leep Weather Facility, named in honor of the WTVT meteorologist who served as a pioneer in television weather forecasting. Leep retired from a 40-year career at WTVT in 1997. Several meteorological instruments are seen on this tower, including radar devices, weather vane, and anemometer. (Courtesy of Mike Clark.)

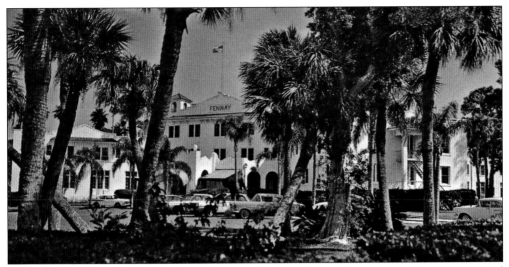

The 110-room Fenway Hotel at 453 Edgewater Drive in Dunedin was completed in 1927 and remained open seasonally until 1961, when it became Trinity College. The former hotel building went vacant in 1988 after Trinity College moved to Pasco County, but three years later the property was purchased by Schiller International University. The building, dubbed Dunedin's most historically valuable structure by the *Tampa Bay Times*, was purchased by the Taoist Tai Chi Society in 2014 and is expected to undergo a massive restoration. (Author's collection.)

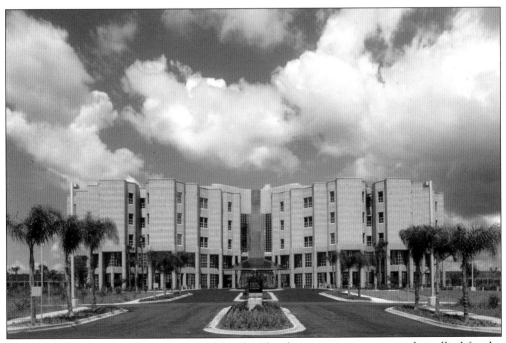

H. Lee Moffitt Cancer Center is named for the Florida state representative who rallied for the construction of a comprehensive cancer center in the Sunshine State. The award-winning cancer center opened on October 27, 1986, on the University of South Florida campus in Tampa and is designated a National Cancer Institute Comprehensive Cancer Center. (Courtesy of the University of South Florida Library Special Collections Department.)

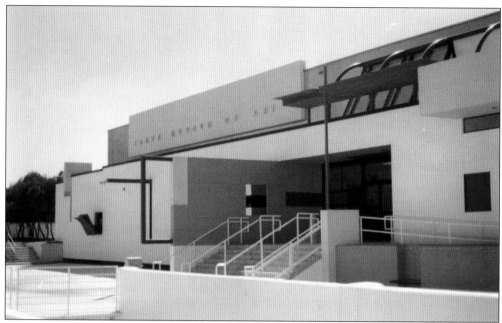

The Tampa Museum of Art was founded in 1979 and was originally located in this downtown building along the Hillsborough River on Ashley Drive adjacent to Curtis Hixon Hall. The facility seen here was demolished to help make way for a new, award-winning building that debuted in 2010 along the Tampa Riverwalk just steps to the north of the original site. (Courtesy of Quality Steel Fabricators, Inc.)

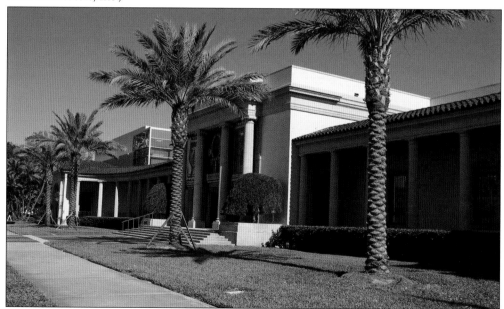

The Museum of Fine Arts in St. Petersburg opened on February 7, 1965. Located at 255 Beach Drive NE, the art museum was spearheaded by Margaret Acheson Stuart and houses a collection that has steadily grown over the years. Expansions to the museum first came in 1974 and today the museum remains a popular destination, drawing some 100,000 visitors each year. (Courtesy of the City of St. Petersburg.)

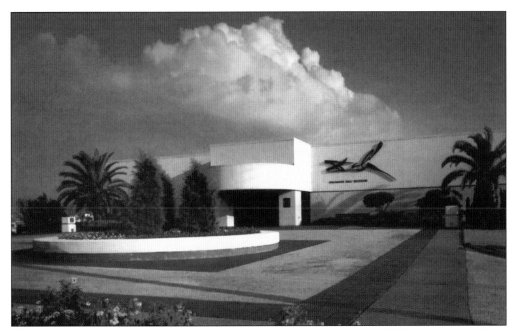

The Salvador Dalí Museum has been a fixture in St. Petersburg since 1982, when this gallery housing hundreds of the Spanish surrealist's pieces was established in southern downtown. In 2011, the extensive collection was moved to a larger, grandiose building on the waterfront near the Mahaffey Theater. (Dalí Museum archives in the USA © Salvador Dalí Museum, Inc., St. Petersburg, Florida, 2015.)

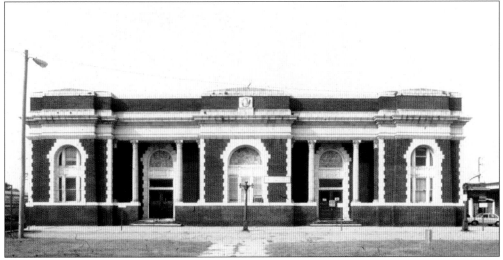

Union Station is located at 601 Nebraska Avenue in Tampa and was built in 1912 to serve passengers on the Atlantic Coast Line, Seaboard Air Line, and Tampa Northern Railroad. The historic building was added to the National Register of Historic Places in 1974, but it closed 10 years later. Union Station was restored and reopened in 1998 and now serves as an Amtrak station for the Silver Star line. (Courtesy of the University of South Florida Library Special Collections Department.)

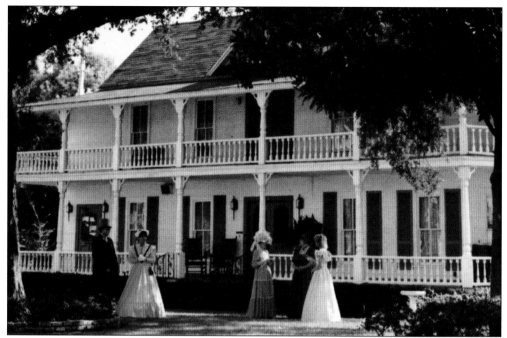

In the late 1850s, John William Brandon and his family arrived in New Hope, an eastern Hillsborough community that would eventually bear his family's name. After John's wife, Martha, died in 1867, the family moved from their homestead in New Hope, seen here, and relocated to Bartow. In 1874, the Brandons returned to their homestead in New Hope, purchased more property, and donated land for a new community school, church, and cemetery. (Courtesy of the University of South Florida Library Special Collections Department.)

The historic Anna Maria city jail was built in 1927. Most offenders housed there were picked up from a local tavern and dance hall on charges of drunkenness and disturbing the peace. The wooden roof structure went up in flames during a windstorm in the 1940s, and the roofless remnant has since become a popular spot for camera-wielding tourists. The jail still stands today near the Anna Maria Island Historical Society Museum at 402 Pine Avenue. (Author's collection.)

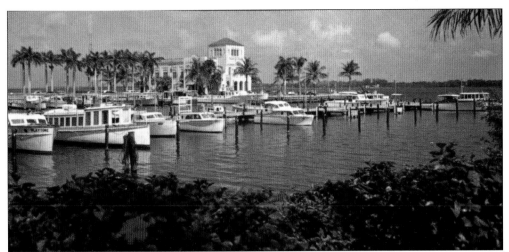

Bradenton's Memorial Pier can be traced back to 1878. The Spanish-style pier structure seen here was built in 1928 and dedicated to 21 Manatee County men who died in World War I. The building has played many roles over the decades, including serving as the first home of the South Florida Museum. The pier overlooking the picturesque Manatee River was spared from demolition in 1974 and lovingly restored. It remains a popular attraction today. (Courtesy of the University of South Florida Library Special Collections Department.)

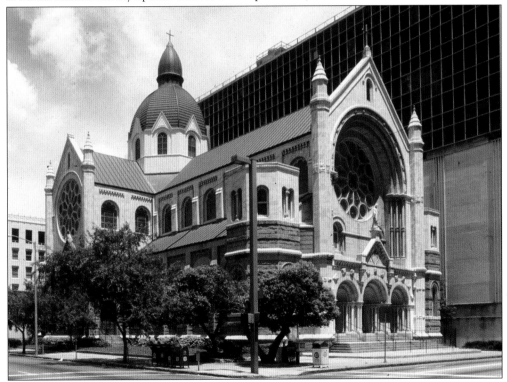

Sacred Heart Catholic Church, located at 509 North Florida Avenue in downtown Tampa, is one of the oldest churches in the city. The church was dedicated in 1905 and features mainly Romanesque Revival architecture. Sacred Heart is widely considered one of the most beautiful churches in the region. (Courtesy of the University of South Florida Library Special Collections Department.)

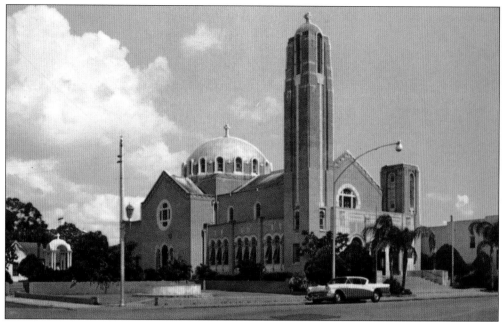

St. Nicholas Greek Orthodox Cathedral is at the heart of the Greek American community in Tarpon Springs. St. Nicholas, at 36 North Pinellas Avenue, hosts the annual Epiphany Day celebration held on January 6, and there is a statue of an Epiphany diver in front of the church. The first St. Nicholas church was built in 1907, and the cathedral seen here was completed in 1943. (Courtesy of the University of South Florida Library Special Collections Department.)

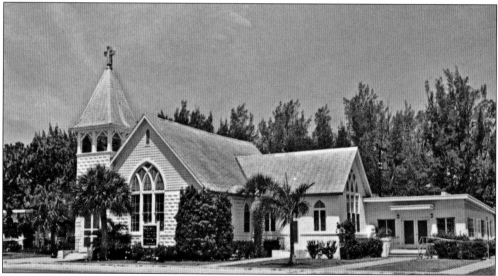

In 1913, Anna Maria Island's John and Caroline Roser Memorial Chapel was built on Pine Street and named for the parents of Charles Roser, who helped develop Anna Maria Island. Roser is credited with inventing the Fig Newton and earned wealth by selling his tasty creation to Nabisco. The nondenominational house of worship at 512 Pine Avenue was expanded over the decades, and now the Roser Memorial Community Church offers Sunday services and hosts many weddings and other special events. (Courtesy of the University of South Florida Library Special Collections Department.)

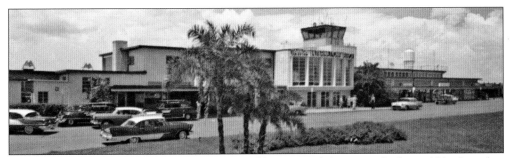

In 1928, the City of Tampa completed Drew Field Municipal Airport, which would be leased to the government in 1940 for use by the Third Air Force as a training facility. After World War II, Drew Field was returned to the city and renamed Tampa International Airport in 1952. (Courtesy of the University of South Florida Library Special Collections Department.)

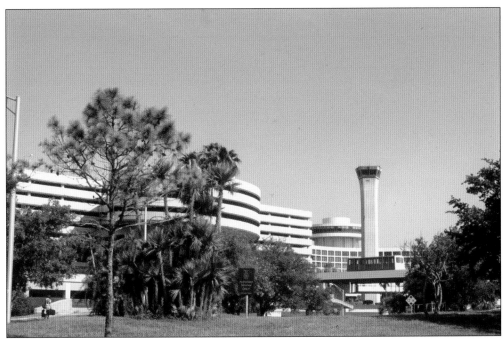

A new Tampa International Airport terminal opened on April 15, 1971. Ranked as one of the top airports in the world, Tampa International sees more than 15 million passengers each year. The airport's distinctive air traffic control tower, standing 227 feet tall, was the world's tallest when it went into service on July 15, 1972. In the background are the Marriott Hotel and the View at CK's revolving rooftop restaurant. (Courtesy of the University of South Florida Library Special Collections Department.)

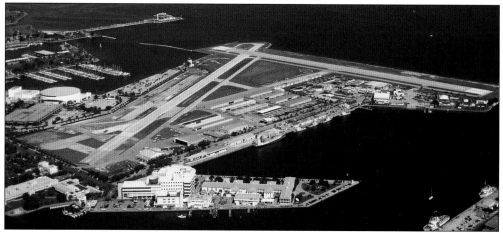

Albert Whitted Airport is located on the downtown St. Petersburg waterfront, from which Tony Jannus departed to inaugurate the St. Petersburg–Tampa Airboat Line on January 1, 1914, marking the first scheduled commercial flight in history. Albert Whitted Airport, originally opened in 1928, is named for a lieutenant who was one of the US. Navy's first naval aviators. (Courtesy of the University of South Florida Library Special Collections Department.)

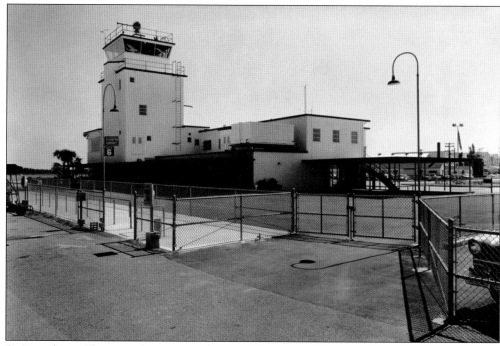

St. Petersburg–Clearwater International Airport, located about six miles north of St. Petersburg, was built in 1941. The airport was acquired by the US Army Air Forces during World War II and returned to Pinellas County after the war. In the baggage claim area stands a replica of the Benoist aircraft that aviator Tony Jannus used in 1914 to fly a scheduled cargo route from St. Petersburg to Tampa, marking the birth of commercial aviation. (Courtesy of the Tampa-Hillsborough Public Library.)

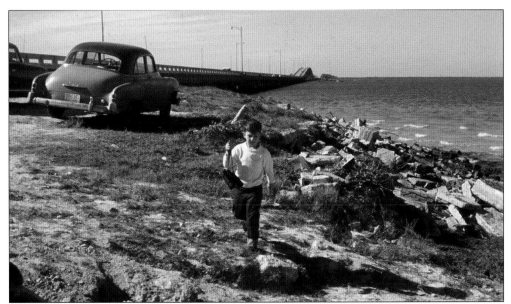

When the original 2.5-mile span of the Gandy Bridge opened in 1924, it linked Tampa to St. Petersburg across Old Tampa Bay and was the longest automobile toll bridge in the world. A new bridge was built in 1956, seen here soon after its opening, and would serve traffic heading toward St. Petersburg. The original span was demolished in 1975 with the completion of a new span, and following the addition of new westbound lanes in 1997, the 1956 structure became the pedestrian Friendship Trail Bridge. The Friendship Trail Bridge is now threatened with demolition. (Courtesy of Hector B. Colado.)

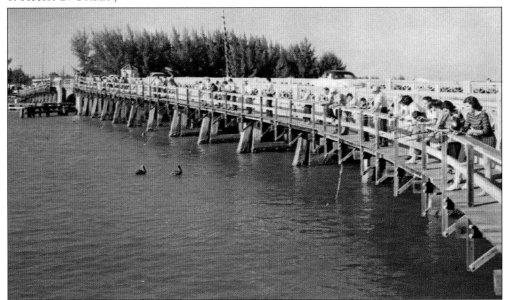

The original John's Pass Bridge, seen here, was operating by the early 1930s as a two-lane drawbridge linking Gulf Boulevard between Treasure Island and Madeira Beach. A new twin span replaced that bridge in 1971 and can be seen in the movie *Summer Rental* when the family arrives in Florida after driving from Atlanta, Georgia. New twin drawbridge spans were completed by 2011. (Author's collection.)

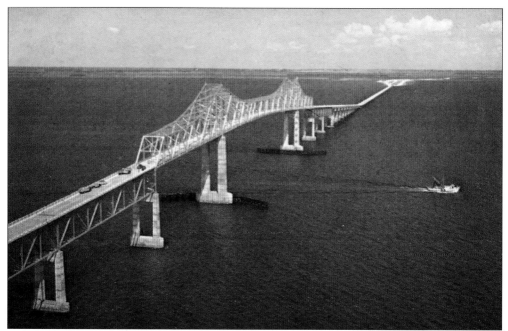

The Sunshine Skyway Bridge opened across Tampa Bay as a single cantilever span in 1954 and linked St. Petersburg to the Gulf Coast Waters Scenic Highway. Increased traffic called for the construction of more lanes. In 1971, an identical second span opened to serve southbound traffic, leaving the pictured span for northbound travelers. (Courtesy of the University of South Florida Library Special Collections Department.)

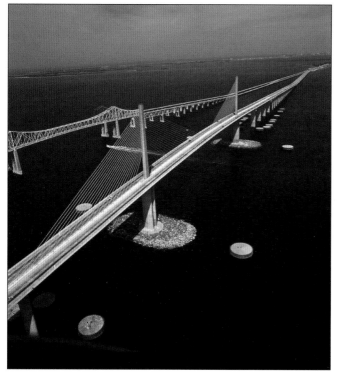

On May 9, 1980, the southbound span of the Sunshine Skyway Bridge partially collapsed after being struck by a freighter called *Summit Venture*, resulting in 35 deaths. In 1987, a steel and concrete cable-stayed bridge seen on the right replaced the two older spans. The original Sunshine Skyway Bridge spans were demolished by 1993, leaving the newer bridge to shine as an iconic, internationally known Tampa Bay landmark. (Courtesy of the Florida State Archive.)

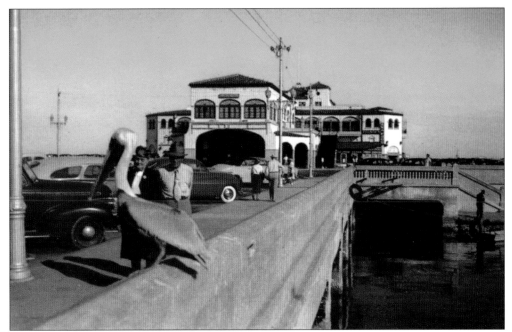

The origins of St. Petersburg's pier date back to 1889, and several different structures preceded the Million Dollar Pier (pictured here), which opened in 1926. The Mediterranean-style structure featured an observation deck, open-air ballroom, and large atrium for hosting events. In the 1950s, a studio was built in the pier's entrance portico for WSUN-TV, the first television station in the Tampa–St. Petersburg television market. In 1967, the Million Dollar Pier closed and was demolished. (Courtesy of the University of South Florida Special Collections Department.)

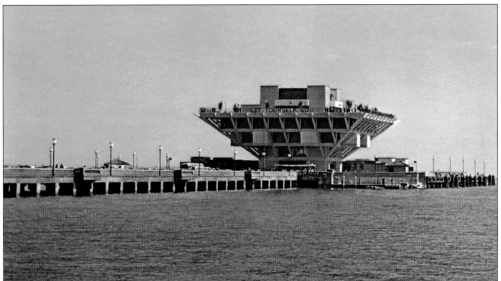

The iconic inverted-pyramid pier opened in 1973, replacing the Million Dollar Pier that stood at the same site. The new pier structure was designed by St. Petersburg architect William B. Harvard Sr., who also designed the Hospitality House at Busch Gardens. The inverted-pyramid pier featured shopping, nightlife, fishing, boat rentals, weekly festivals, and a popular branch location of the Columbia Restaurant. The pier closed on May 31, 2013, and faces an uncertain future. (Author's collection.)

DISCOVER THOUSANDS OF LOCAL HISTORY BOOKS FEATURING MILLIONS OF VINTAGE IMAGES

Arcadia Publishing, the leading local history publisher in the United States, is committed to making history accessible and meaningful through publishing books that celebrate and preserve the heritage of America's people and places.

Find more books like this at
www.arcadiapublishing.com

Search for your hometown history, your old stomping grounds, and even your favorite sports team.